D0907600

IMAGES
of America

OSAGE BEACH

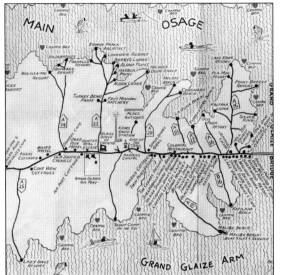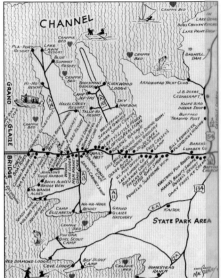

The two parts of this 1960 map show Osage Beach east and west of the Grand Glaize Bridge. The city limits end today on the right half of the map (east) where the Buffalo Trading Post is shown north of the Highway 54-134 junction. Highway 134 is now Highway 42. The entrance to Lake of the Ozarks State Park is at the second fork in the road (7H) on Highway 42 south of the Highway 54-134 junction. The left half of the map shows Osage Beach west of the bridge. The city limits end today a few hundred yards past A25, which is now called Lazy Days Road. Most of the Grand Glaize Arm of the lake is considered part of Osage Beach, but the full length of the Grand Glaize Arm is not shown on the map.

ON THE COVER: The Grand Glaize Café, often called the Hot Fish Café, was established just west of the Grand Glaize Bridge around 1940. The building currently houses a restaurant called the Potted Steer. This landmark building has housed restaurants since the day it was built. See pages 62–63 for more about the history of this site.

IMAGES
of America

OSAGE BEACH

H. Dwight Weaver

NRC CASS COUNTY PUBLIC LIBRARY
 400 E. MECHANIC
 HARRISONVILLE, MO 64701

ARCADIA
PUBLISHING

0 0022 0469767 2

Copyright © 2012 by H. Dwight Weaver
ISBN 978-0-7385-9422-4

Published by Arcadia Publishing
Charleston, South Carolina

Printed in the United States of America

Library of Congress Control Number: 2012935149

For all general information, please contact Arcadia Publishing:
Telephone 843-853-2070
Fax 843-853-0044
E-mail sales@arcadiapublishing.com
For customer service and orders:
Toll-Free 1-888-313-2665

Visit us on the Internet at www.arcadiapublishing.com

*This book is dedicated to the photographers whose postcards
created a visual history of Osage Beach during its early years.*

CONTENTS

ACKNOWLEDGMENTS

I am grateful to the following for their help: Alan Sullivan of Ameren Missouri, for his continuing encouragement in my efforts to chronicle the history of Lake of the Ozarks; to the Camden County Historical Society for images and historical information; to Dale Jeffries, who grew up in the days covered by this book and whose family contributed much to the early history of Osage Beach; to James Brooks, for images from his grandfather's collection, for he is the grandson of Tex Bemis; to Lynn Morrow, Missouri State Archives, Local Records Preservation Program, for his encouragement, and to the staff of the Missouri State Archives for helping me locate needed images; to Sue Dutton, for sharing some of the images her parents acquired when they participated in several of the square dance institutes at Kirkwood Lodge in the 1950s; to my wife, Rosie, who has an even better memory of people and places in Osage Beach than I do; and finally, to the staff of Arcadia Publishing, who convinced me that since I had produced two other books for Arcadia, I should do this one as well. All images in this book, unless otherwise noted, are from the author's collection.

INTRODUCTION

Osage Beach is located in the northern Ozarks, 40 miles southwest of Jefferson City, Missouri, on US Highway 54, where the Grand Glaize Bridge crosses Lake of the Ozarks. The lake, which was formed in 1931 by the construction of the Bagnell Dam, is embedded in the rugged hills of the Ozarks, giving it a special charm and scenic beauty. The story of Osage Beach, located in the heart of the lake's recreational area, actually began 50 years before the creation of Lake of the Ozarks.

In the late 1800s, as steamboats began to regularly navigate the meandering Osage River, riverboat pilots started naming shoals, islands, bluffs, and other geographic features. Place names helped them determine where they were along the river at any given time as well as designated landings where commerce could be conducted. A feature at the confluence of the Grand Glaize and Osage Rivers in Camden County was named Zebra, because a bluff at that location was streaked with mineral stains that people claimed made it look like the hide of a zebra.

The Zebra landing became a busy railroad tie-shipping site after 1885, as white-oak timber was harvested from the hills along the Grand Glaize. The ties were loaded onto barges or tossed into the Osage and linked together in long rafts to be floated downstream 24 miles to the village of Bagnell, in Miller County. There, the ties were loaded onto the Bagnell Branch Railroad, a spur of the Southern Pacific Railroad, and shipped abroad. The tie industry sparked settlement at the mouth of Grand Glaize River. In 1886, the Zebra post office was established, and the village of Zebra was born.

The Osage River was notorious for flooding; therefore, only a warehouse and a few other structures were located near the river landing. Most of Zebra was perched on an adjacent ridge. US Highway 15, which became Highway 54 in 1925, passed near Zebra and crossed Grand Glaize River about a mile and a half upstream from the Osage River. The Grand Glaize valley was destined to become a major arm of Lake of the Ozarks, so a new bridge—one that crossed the entire valley high in the air—was built. The new Grand Glaize Bridge soon became popularly known as the "Upside Down Bridge," because of its design.

Even before the lake basin filled, a group of investors from Jefferson City formed the Osage Development Company and began promoting a resort development just east of the Grand Glaize Bridge. By 1934, a small, but ambitious, resort community had taken shape on both sides of the bridge. Some of the new locals did not like the name "Zebra" for their post office, so a campaign to change the name was led by Mrs. A.B. Cannady, who had purchased land along the highway east of the bridge for a restaurant and grocery store. The effort was successful, and in 1935, the Zebra post office, which sat east of the bridge, was renamed Osage Beach.

The boundaries of Osage Beach were uncertain, as development gradually spread along the highway, lake roads, and lakeshore. An attempt to incorporate the community was made in 1959, but complications delayed it until a special election in 1965 finally succeeded. Boundaries were then officially established, but the city has continued to expand. Today, the incorporated portion

of Osage Beach includes more than 10 square miles and is shoulder-to-shoulder with Lake of the Ozarks State Park, Missouri's largest state park.

The first two decades of tourism growth in Osage Beach were slow due to the Great Depression followed by rationing during World War II. Visitors came primarily on weekends, and resort development was widely scattered. Roadside businesses clustered mainly where lake roads joined Highway 54. With the end of World War II, the economy improved, and tourism brought a rush of new development to the lake area. Osage Beach began to blossom as scores of mom-and-pop resorts and other businesses opened. The architecture of the built environment took on a new face as log and rock cottages, common to the area in the 1930s and 1940s, gave way to newer construction styles. The recreational scene evolved into one that focused upon fishing and recreational boating laced with a strong flavor of country-western entertainment. Rodeos, hayrides, trail rides, square dances, and country music shows flourished. This would last for several decades.

In the 1960s, the Osage Beach area acquired its first large corporate resort complex, Tan-Tar-A. This brought more outside corporate attention to the community. In the 1970s, significant improvements to Highway 54 beyond the lake area made Osage Beach more accessible, and national franchise operations awakened to the potential of Lake of the Ozarks. Osage Beach saw the arrival of its first McDonald's restaurant. As the 1980s and 1990s ran their course, the small mom-and-pop resorts rapidly disappeared and were replaced by larger, often corporate, operations. Condominiums rose from the shoreline, and by the year 2000, the highway corridor through Osage Beach had expanded from two lanes to five. Traffic was no longer light and seasonal, but heavy year-round and often bumper-to-bumper in the summer. The lake had become a second home for many, especially retirees.

The corridor of old Highway 54 through Osage Beach, now called the Osage Beach Parkway, today resembles the business corridors approaching most major cities—lot-to-lot car and boat dealerships, shopping malls, big-box stores, and franchise operations of every kind. The lakeshore is, in places, dominated by condominium, townhouse, and villa complexes along with very pricey homes. The lake itself has become a busy waterway in the spring, summer, and fall months with recreational craft of every size, description, and power. A new limited-access highway, called the Highway 54 Expressway, has been carved through Osage Beach, bringing highway overpasses, deep massive road cuts, and complex interchanges that will forever change the look of this once-romantic, laid-back, quiet resort community. The expressway opened in 2011.

The City of Osage Beach is linear in its layout, with its business community built along the shoulders of the Osage Beach Parkway for eight miles and along tributary lake roads and the lakeshore. As a consequence, the layout of this book is linear and follows the parkway. Chapter one features the Grand Glaize Bridge and its construction. Chapter two features early businesses and buildings located east of the bridge. Chapter three follows the highway west of the bridge. Chapter four is an overview of the types of attractions and entertainment visitors to Osage Beach enjoyed in the 1950s, 1960s, and 1970s.

Most of the built environment of the early decades has vanished, but it has not been entirely forgotten. This book dips into a treasury of images created by early promotional photographers who worked their magic without realizing they were creating a visual history of Osage Beach that would long outlive them.

One

THE GRAND
GLAIZE BRIDGE

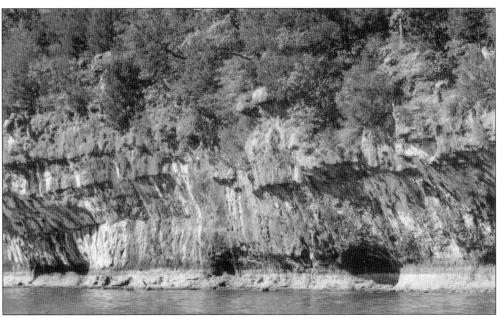

This black-and-white-streaked bluff on the Grand Glaize in the Osage Beach area bears the mineral-stain pattern that encouraged early riverboat pilots to name one such bluff along the Osage River "Zebra," giving the predecessor of Osage Beach its name. The rock contains the mineral manganese, which is leached from the rock by groundwater and then deposited on the bluff face.

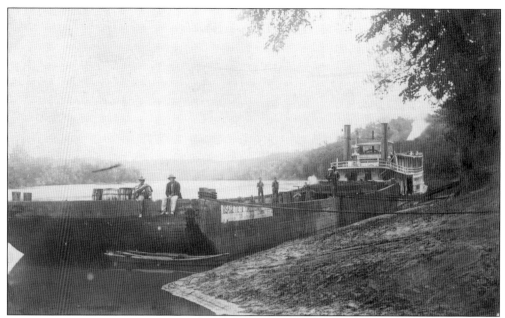

One of the huge barges used by the Osage Tie and Timber Company to haul freight and railroad ties is pictured here. These barges were generally pushed up and down the Osage River by steamboats, but it is uncertain if the steamboat seen in this c. 1900 photograph is the one that pushed this particular barge. (Courtesy of the Missouri State Archives.)

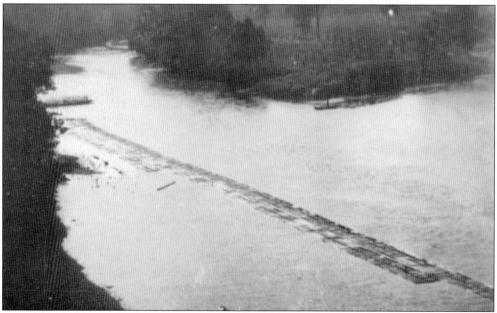

Tie rafts sometimes linked up to 1,000 ties, but the longer the raft, the more difficult it was to maneuver around river bends. Six or more men rode the raft and used poles to steer it. Riding a raft was a skilled and dangerous undertaking. In the 1890s and early 1900s, the men were not known to wear personal flotation devices (lifejackets). (Courtesy of the Camden County Historical Society.)

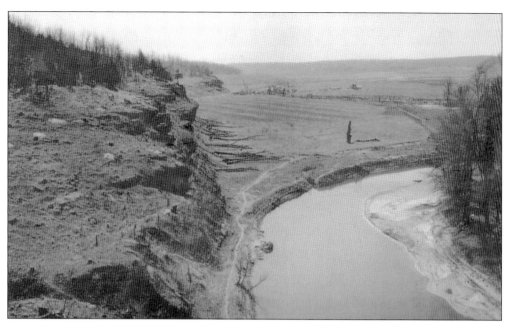

This 1930 photograph shows the Grand Glaize valley near the river's confluence with the Osage River. The basin has been cleared of its timber, and in the distance, work on bridge piers is just getting underway. (Courtesy of Ameren Missouri, formerly AmerenUE.)

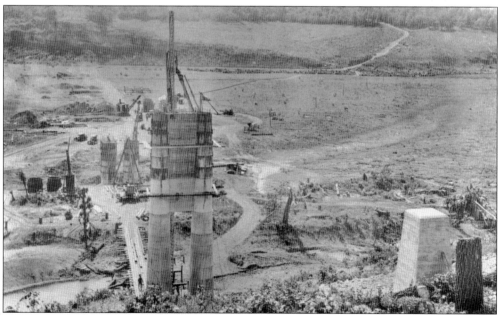

Construction of the Grand Glaize Bridge began in March 1930. The Union Electric Light and Power Company financed the rerouting of Highway 54 and bridge construction. Stone and Webster Engineering supervised the work in cooperation with the Missouri State Highway Department. (Courtesy of Ameren Missouri.)

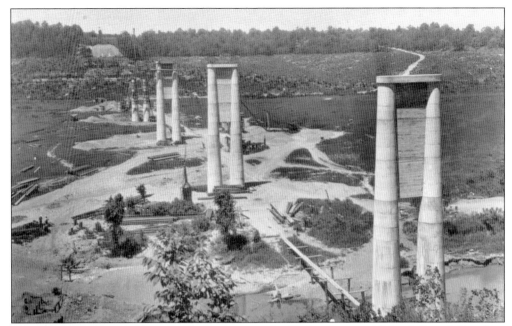

The bridge was designed by consulting engineers Leif J. Sverdrup and John I. Parcel. Sverdrup was a former employee of the Missouri State Highway Department, and Parcel was a professor of structural engineering at the University of Minnesota. Their newly formed company was headquartered in St. Louis. (Courtesy of Ameren Missouri.)

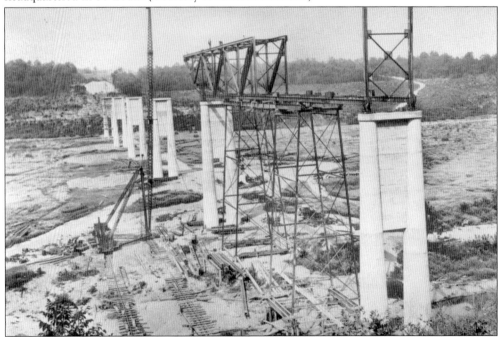

The bridge had a span of 1,630 feet and rested on piers anchored in bedrock. It also had an unusual configuration with the trusses underneath the deck, giving it the appearance of a conventional bridge that was "upside down," hence its nickname, the "Upside Down Bridge." This rare design afforded travelers an unimpeded view of the lake. (Courtesy of Ameren Missouri.)

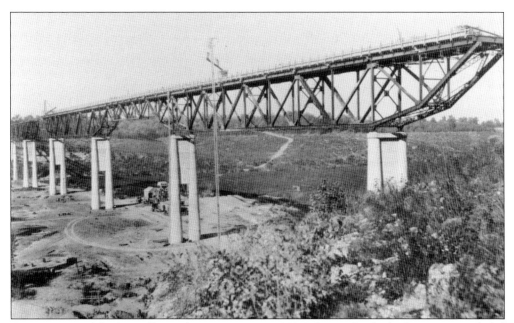

Construction of the Bagnell Dam began in August 1929. Laborers for the bridge project included 50 to 60 men who had been borrowed from the dam project. Except for painting, the construction of the bridge was completed by January 9, 1931, nearly five months before the dam was completed and Lake of the Ozarks basin became filled with water. (Courtesy of Ameren Missouri.)

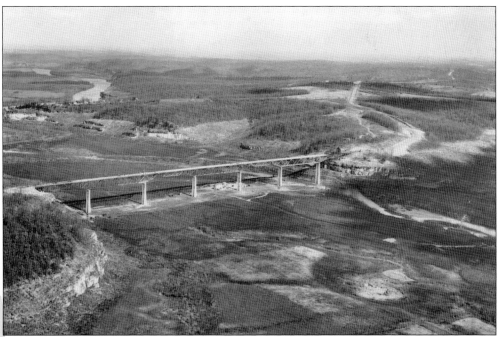

In this view of the Grand Glaize Bridge after construction, the Osage River is visible in the upper left, but not the confluence of the Grand Glaize and Osage Rivers. The view of the new highway route (upper right) does not extend all the way to Bagnell Dam. (Courtesy of Ameren Missouri.)

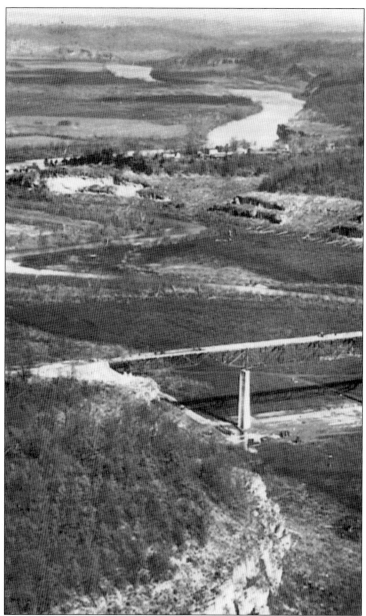

In this enlarged view of a portion of the bottom photograph on page 13, the village of Zebra is visible, strung out along the ridge before the highway project was complete. The road that passed along the ridge was known as Hi-Low Road, because it began near the river landing (not visible at left). Dwellings on the ridge were not moved, but several merchants did relocate along the new highway. Beyond Zebra are the Osage and the nose of Gambler's Bluff, jutting out over the river. Williams Hollow lies between it and Zebra ridge. Williams Cave, now inundated, has its entrance in the hollow, and some of the cave's water-filled passages still lie deep beneath a portion of Osage Beach. The cave gained fame in the 1800s when a man named Williams owned the property. He had several children, and when strangers approached, he would hide his children in the cave. No one was certain why. During a separate incident in 1888, several children exploring the cave had to be rescued. (Courtesy of Ameren Missouri.)

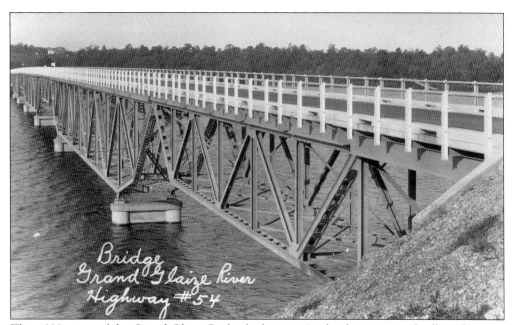

This 1930s view of the Grand Glaize Bridge looks west. In the distance is a dwelling that may have been the William Jeffries home along what is Jeffries Road today. The land at both ends of the bridge and on both sides were prime locations for early businesses. The side of the bridge visible above (lower right) is where Chet's Anchor Inn was located in the 1940s.

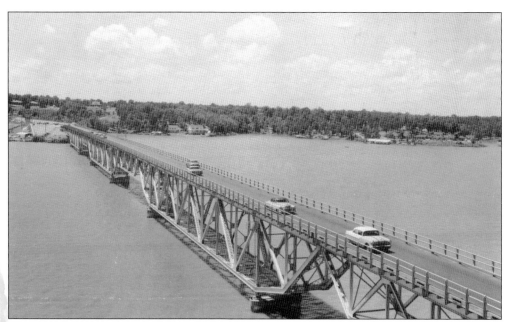

The Grand Glaize Bridge was built during the Great Depression at a cost of $295,440. It was in service until 1994, when it was demolished for twin bridges of a newer design. The engineers who designed the original bridge also designed two other historic bridges that crossed Lake of the Ozarks. This photograph looks west.

This 1950s view of the Grand Glaize Bridge looks north. The bridge is three-quarters of a mile from the confluence of the Grand Glaize and Osage Rivers (to the left). The extensive cove in the upper right is two-mile long Watson Hollow Cove. The pre-lake route of Highway 54 traveled down Watson Hollow. (Courtesy of the Missouri State Archives.)

This view of the Grand Glaize Bridge looks west, showing the wide mouth of Watson Hollow Cove. When the water is at a 660-foot elevation, which is a full reservoir, the cove has depths of up to 50 feet. Little development seems apparent in this view, but several resorts were in business along the cove when this photograph was taken. (Courtesy of the Missouri State Archives.)

Two

ZEBRA TO RIVERVIEW CHURCH

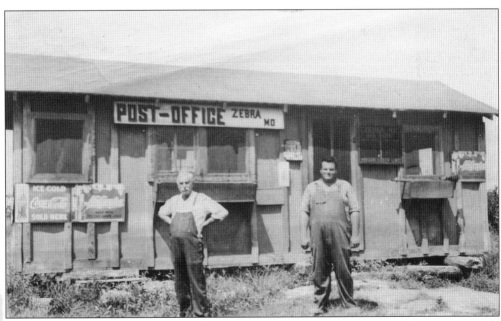

The Zebra post office opened in 1886 and was first located in Uncle Tom Ezard's store. His wife, Theresa; his daughter Maud; and son-in-law John McCrory maintained it. With the coming of Lake of the Ozarks, the post office was relocated along the new highway. Shown here are postmaster E.W. Tuttle (left) and his assistant Robin Tuttle.

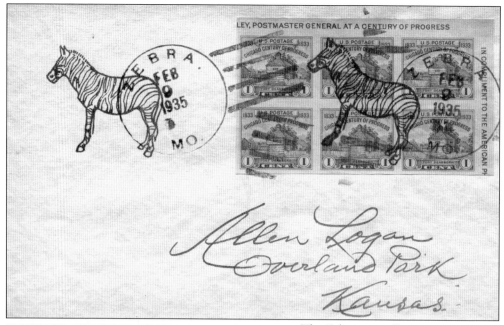

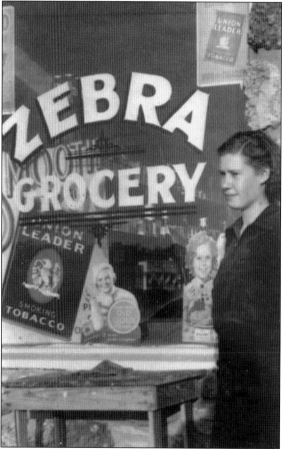

The Zebra post office name was discontinued in 1935 and changed to Osage Beach. The Zebra post office had an interesting postmark (pictured) on one of the last letters postmarked there. The closing of any post office is usually a sensitive topic for the people who depend upon it. Fortunately, this post office did not cease, but just changed its name.

Zebra had only a few merchants, and most apparently did not move to be along the new route for Highway 54. Shown here is Jessie Scott, a member of the Scott family, who did, in fact, move. They owned and operated the Zebra Grocery, which was closed by the 1960s. The building was abandoned, but it was not demolished until 1996. (Courtesy of the Camden County Historical Society.)

This vintage, big-letter postcard promoting Osage Beach is a curiosity for collectors of Lake of the Ozarks memorabilia. While there are similar cards from the 1940s and 1950s that promote Lake of the Ozarks, Osage Beach is the only incorporated town within the lake area that can boast of having its own big-letter postcard in this style.

In 1941, Osage Beach was described in *Missouri: A Guide to the "Show Me" State* as a tiny resort village and one of the early projects planned by real estate promoters. A town was platted and a few lots sold when Bagnell Dam was first proposed in 1928. The economic depression halted development after 1930. One of the dignitaries who bought a lot was Missouri senator Roscoe C. Patterson.

OSAGE BEACH

GATEWAY TO AMERICA'S LARGEST ARTIFICIAL LAKE

On Federal Highway No. 54 and Magnificent New

Lake of the Ozarks

Moderate-Priced Lots for Recreational and Business Sites

Modern Hotel and Cottage Accommodations

"Every Map of the Lake Region is a Prophesy for the Future Development of Osage Beach"

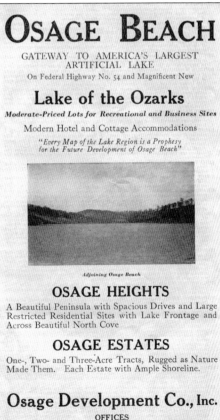

Adjoining Osage Beach

OSAGE HEIGHTS

A Beautiful Peninsula with Spacious Drives and Large Restricted Residential Sites with Lake Frontage and Across Beautiful North Cove

OSAGE ESTATES

One-, Two- and Three-Acre Tracts, Rugged as Nature Made Them. Each Estate with Ample Shoreline.

Osage Development Co., Inc.

OFFICES

214 E High St.
JEFFERSON CITY, MO.

OSAGE BEACH
Camden County, Mo.

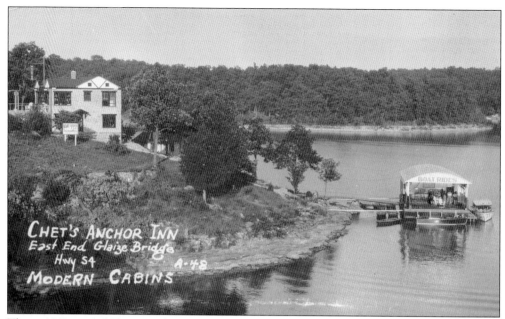

This c. 1948 view of Chet's Anchor Inn was taken from the Grand Glaize Bridge looking northeast. Chet Mason Hymes bought the property around 1942. His business grew rapidly and soon covered much of the sloping ground. His parents owned Hymes Kottage Kamp No. 1 and No. 2 near the west end of the bridge.

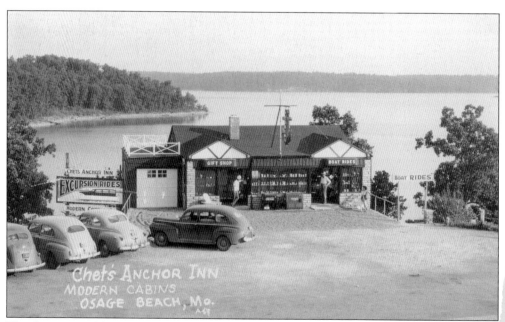

This front view of the two-level structure seen in the top photograph was also taken around 1948. There were rental cabins on the hillside to the left of the gift shop. A variety of excursions were available as well as seaplane rides. Lake of the Ozarks covers a vast area, and its outline from a high altitude resembles a Chinese dragon.

Chet Hymes sold the gift shop and cottages in 1953. He moved farther west along the highway and established Chet's House of Gifts and Eats and a go-kart and bumper car business called Chet's Fun Spot. The barge where the excursion boat business was operated was also used to haul gravel when Bagnell Dam was under construction.

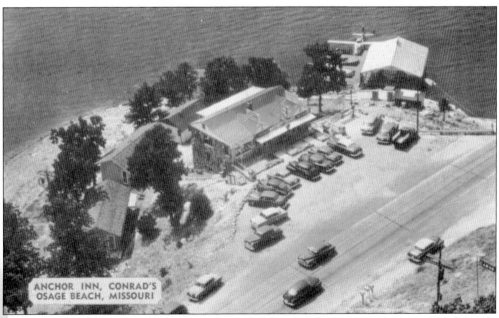

Several cottages can be seen in this view. From 1953 to 1955, the business was called Conrad's Anchor Inn and was operated by Herb and Mable Conrad. The parking area was built on surplus fill that had been excavated when the east approach to the Grand Glaize Bridge was built. Around 1956, the property and business enterprises were sold and became Link's Landing.

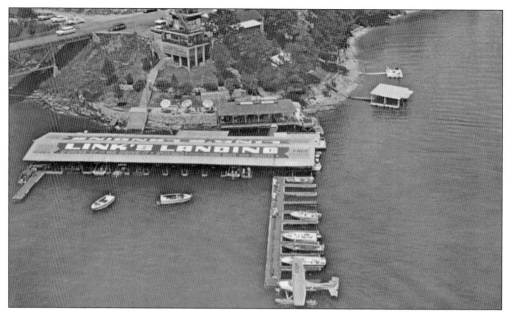

Link's Landing added considerably to the former Anchor Inn operation by expanding the boating facilities. By the 1970s, it was considered the largest marina on the lake, berthing 210 boats. Its slogan was, "if it floats, we rent it." The construction of a new Grand Glaize Bridge in the 1990s claimed the Link's property, and the marina no longer exists.

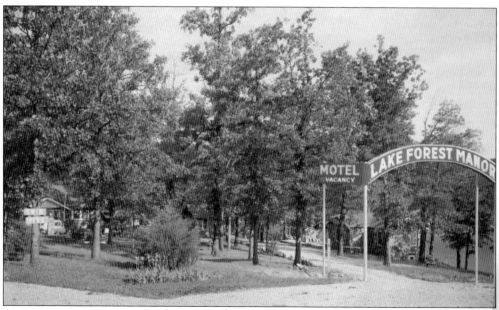

Lake Forest Manor was about 1,200 feet east of Chet's Anchor Inn and, subsequently, Link's Landing. Lake Forest Manor opened in the late 1940s. Today, the Osage Beach Parkway exits onto the Highway 54 Expressway's east approach to the Grand Glaize Bridge near where this resort property used to be situated.

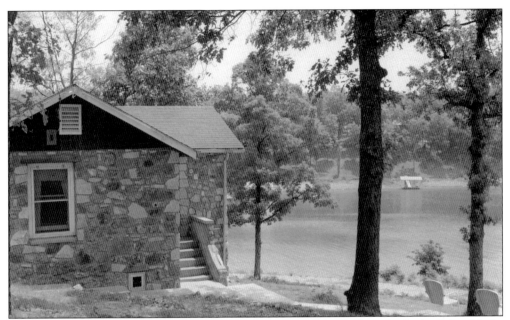

The first lengthy cove trending northeast just south of the Grand Glaize Bridge lay behind Lake Forest Manor. The strip of land between the highway and the cove was narrow, perhaps just a few acres wide, but it was considered prime resort property because it gave the business both highway and lake frontage.

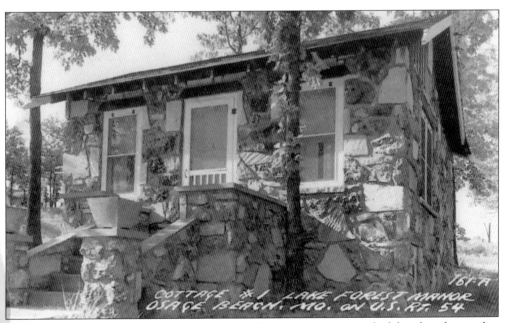

A close look at this neat little rock cottage at Lake Forest Manor reveals slabs of sandstone that exhibit ripple marks from when the rock formed on the sandy shores of an inland sea 450 to 500 million years ago. This rock came from a local quarry. The proprietor of Lake Forest Manor in the 1950s was Ernest Ochse.

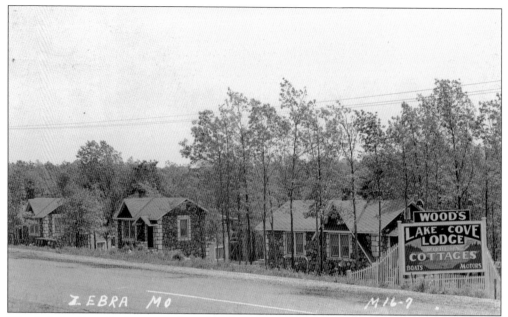

Woods Lake Cove Lodge opened in the early 1930s and was located northeast of the Grand Glaize Bridge and east of Lake Forest Manor. This image comes from a postcard that gives a clue to when the photograph was taken. It identifies the location as Zebra. The same postcard was reissued a few years later with the location as Osage Beach.

The Woods Lake Cove Lodge waterfront was marked with the word "WOODS" on a storage building and a flag at the west end of the beach. There was a long, narrow, manmade sand beach, which by the 1960s was lighted at night. This is the view that Johnson's Snug Harbor Resort had from the opposite side of the cove.

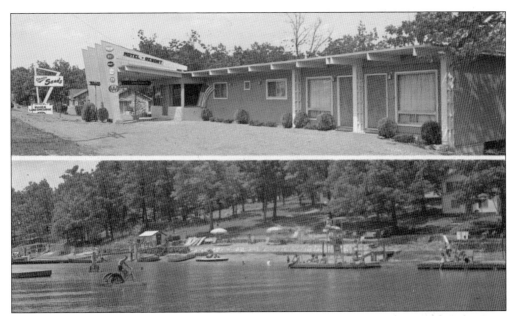

The Ozark Sands Motel was built in the 1950s on property adjacent to the Woods Lake Cove Lodge. In 1964, the lodge was sold to Gene and Laverne Robinson, who owned the Ozarks Sands Motel, giving them additional units and also a beach area. Woods Lake Cove Lodge had 1,000 feet of shoreline. The motel sign also says, "Woods Lake Cove Lodge."

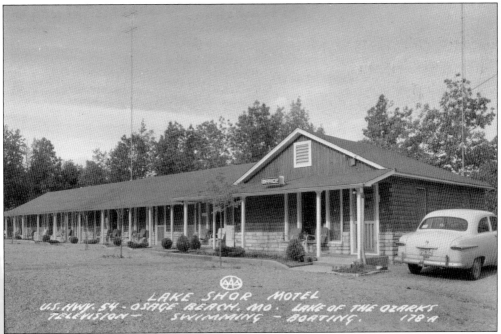

In 1952, the Lake Shore Motel also opened near the Woods Lake Cove Lodge. The word "motel" was just beginning to come into vogue for highway lodging places in the lake area when the Woods Lake Cove Lodge, the Lake Shore Motel, and the Ozark Sands Motel opened. These lodging places no longer exist.

ANNOUNCING — The New Location of WILSON'S HILL

Six miles west of Bagnell Dam, turn south on Zebra road. Cabins are all modern and cooking is done with Skelgas. Finest bathing beach on the lake, cool south breeze. Boats and guides. Ice water and ice storage. We can accommodate from two to ten people in each cabin. Post Office address, Osage Beach, Missouri.

Ed Wilson of Wilson's Hill started his business in 1932. It was located one-quarter of a mile from Bagnell Dam, but Wilson sold that place and bought this one around 1934. He created this postcard to announce his new location. The move set him back financially, so he sent this postcard to a creditor stating that he did intend to pay his bill and was temporarily short of cash.

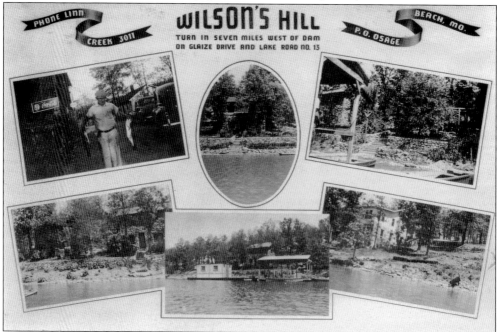

Ed Wilson obviously paid his bills, since this postcard—made a few years later—shows considerable improvements to his resort in Osage Beach. For some reason, he seemed uncertain as to just how far Wilson's Hill was from Bagnell Dam. The top postcard gives the distance as six miles, while this one states that his resort was seven miles from the dam.

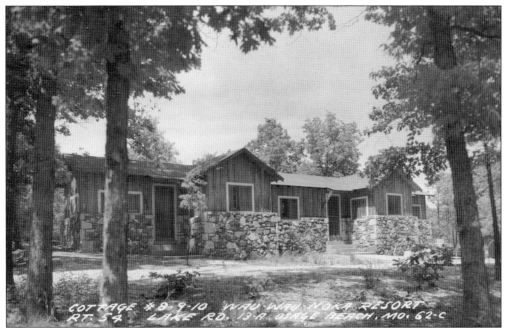

Wau Wau Noka Resort was in Wilson Hill's neighborhood. Leo M. and Gertrude Gies opened it in the late 1940s. The resort name was unusual because it sounded like a scout camp. Opinions differ on the meaning; some sources say "earth and water," and others say "beautiful water." It is believed to be from the Chippewa language. Perhaps the Gies were from Wisconsin, where that language had been spoken.

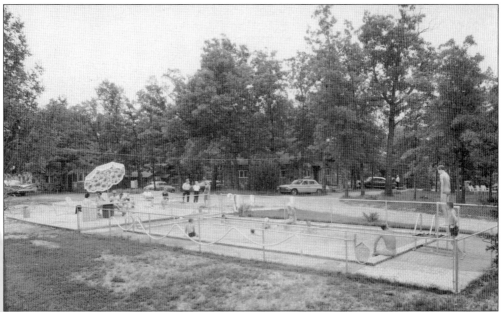

Wau Wau Noka Resort, which no longer exists, was accessible by Passover Road. The resort was sold to Joe and Betty Ketterlin around 1960, and in 1961, they installed the swimming pool seen here. Many motels and resorts had pools for the convenience of their guests, because many guests preferred swimming in a pool as opposed to swimming in the lake.

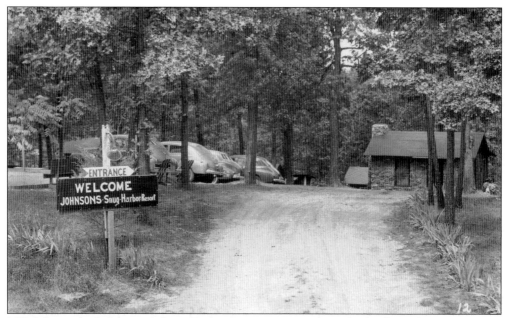

M.P. Johnson built Johnson's Snug Harbor Resort in 1940 along the banks of the same cove as Woods Lake Cove Lodge, but on the opposite side of the cove. To reach Snug Harbor, tourists used Passover Road. Johnson started with eight fully furnished, gas-heated housekeeping frame cottages, but also had a few rock cottages.

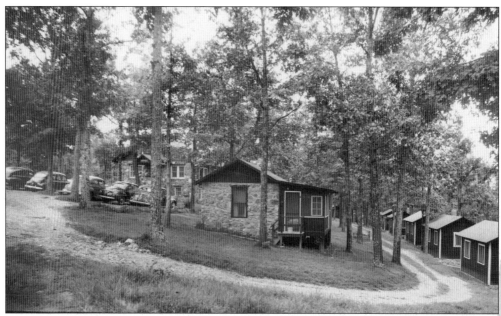

Johnson was a well-known resort owner. After getting his cottages built, he turned his attention to his waterfront, building a dock for his boats and promoting swimming, boating, and fishing. He advertised that he had horseshoes, croquet, and shuffleboard for adults and a playground for children. He built a covered boat dock in 1955.

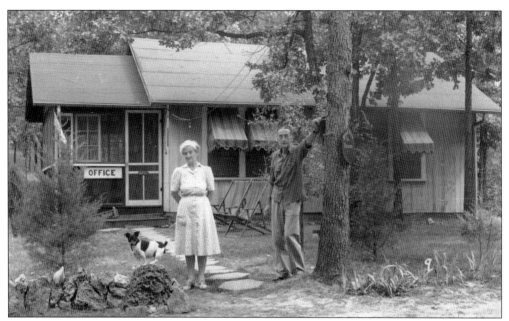

This photograph shows Mr. and Mrs. M.P. Johnson along with the family dog. They are standing in front of a cottage—the one they started with—that also served as the resort office. As time passed, they built a large rock home, which can be seen in the photograph at the bottom of the previous page, beyond the group of parked cars.

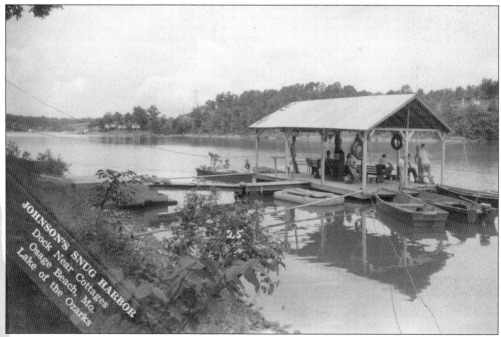

In the 1940s, the boat dock facilities at Johnson's Snug Harbor were modest. The inflatable raft with a platform on it was for the use of swimmers. The white cottages in the far distance were at Chet's Anchor Inn. The Grand Glaize Bridge, though difficult to see, is to the left of the cottages.

In 1959, M.P. Johnson sold to Gordon C. Fender, who greatly improved the swimming and fishing facilities. He also added cottages and made improvements to the covered boat dock. Fender sold to Larry and Carolyn Moore, who added "marina" to the business name. Snug Harbor Resort no longer exists.

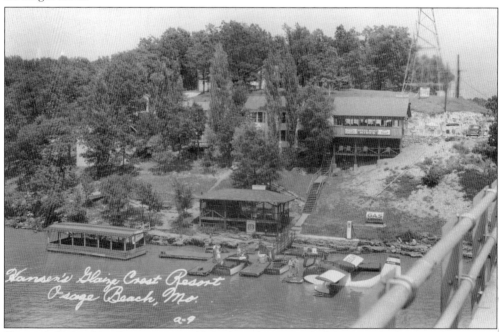

Hansen's Glaize Crest Resort was established on the east end of the Grand Glaize Bridge, toward the north side. They offered seaplane, speedboat, cruiser, and surfboard rides. The cottages are not visible in this view. In the late 1950s, it became Meyer's Glaize Crest Resort and continued to operate until the 1960s. The resort is now gone.

The Clown, or the "Floating Clown" Restaurant, opened around 1960, just 300 yards from the Grand Glaize Bridge. For decades, it served beer, chicken, shrimp, and hamburgers to boaters dockside, but recently ceased doing so. The restaurant is still in business and has long been owned by Dick and Kim Ebling.

The Hi-Ho Resort was built in the late 1940s in a very visible location along the Grand Glaize Arm, east of the Grand Glaize Bridge. Until the early 1950s, it was known as Riley's Hi-Ho Hideout, but then changed to Merry Mac's Hi-Ho Hideout. The resort ceased advertising in chamber publications around 1961, but remained in the local telephone book until 1969.

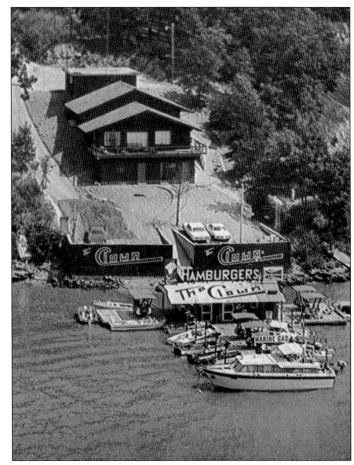

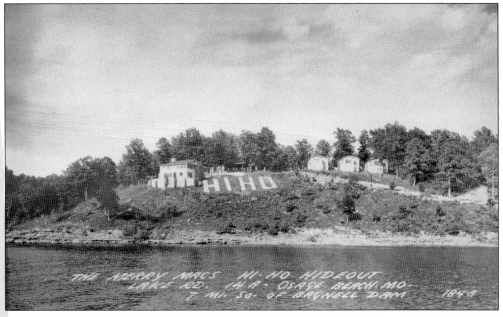

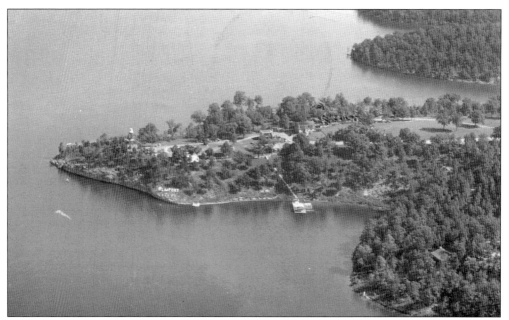

Pla-Port was, without a doubt, one of the most prominent resorts during the first three decades of Osage Beach history. Its popularity with newlyweds stemmed from the resort's lighthouse, which stood high on a point towering above the trees. At night, a rotating green light in the tower could be seen for a distance of 14 miles. The setting was park-like.

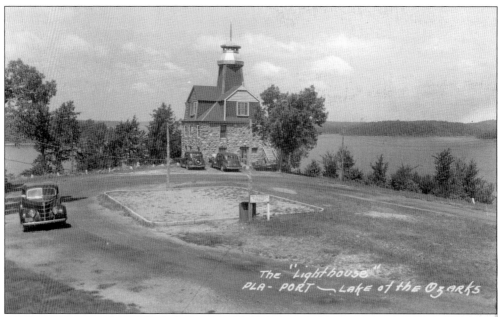

Adding to the romance of the lighthouse at Pla-Port were the honeymoon suites on the second and third floors. The ground level had a dance floor, a small gift shop, and a concession stand. The man who designed the lighthouse, Thomas Forrester, a noted architect of the area, also built it.

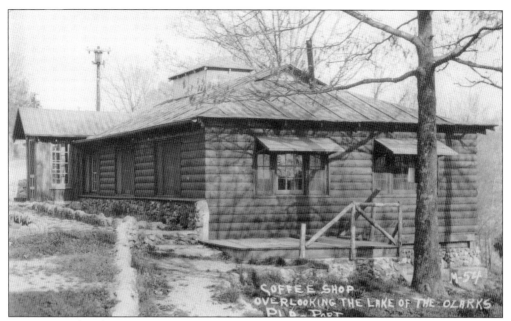

Forrester employed a crew of 35 men to build the lighthouse, which stood on Observation Heights, in the old Zebra location where Hi-Low Road left the ridge and went steeply downhill to the riverboat landing. Forrester had his own resort (see page 79). The coffee shop pictured here was a popular mealtime destination, even for locals.

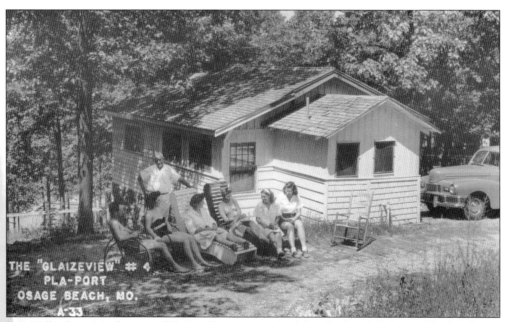

L.A. Kelly, the original owner of Pla-Port Resort, conceived the idea for a lighthouse. The lighthouse was demolished in the early 1960s. The cottages for the resort were scattered along both sides of the peninsula. As they were built over a period of several years, their architectural design varied. Every unit available had a name with a local flavor.

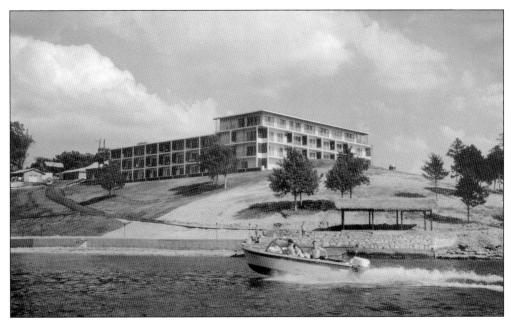

The demise of Pla-Port Resort eventually gave rise to a new resort known as Mai-Tai. Its decorative theme was Polynesian. Some individual cottages were removed, and most accommodations for guests were in the massive condominium-like building seen above. The resort was short-lived. (Courtesy of the Missouri State Archives.)

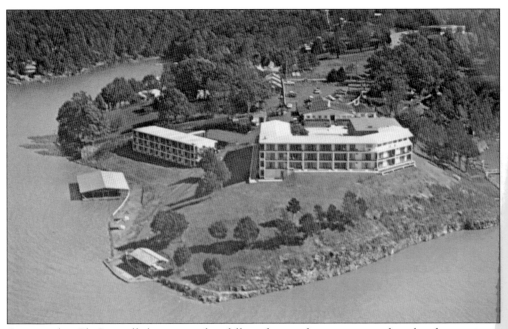

Compared to Pla-Port, all the resorts that followed it on this point were short-lived operations. Other resorts included Osage House (shown here) and Breckenridge. Today, this point is covered with the condominium complex known as Lands' End. Deep beneath Williams Hollow Cove towards the upper left is the inundated entrance to historic Williams Cave.

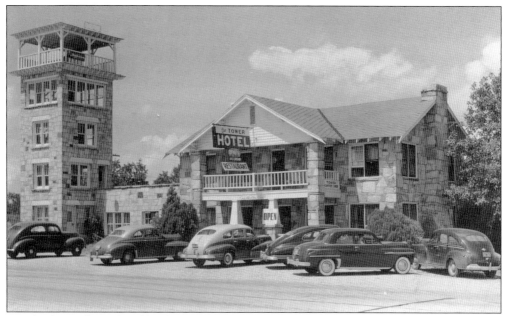

Not far from where the old Zebra post office once stood, E.V. Tuttle built this interesting rock hotel in the 1930s. It had an attached observation tower and was called the Buena Vista Hotel. A later owner named it the Tower Hotel. It would sell yet again and become Van's Tower Restaurant. Such roadside observation towers were once popular in the lake area.

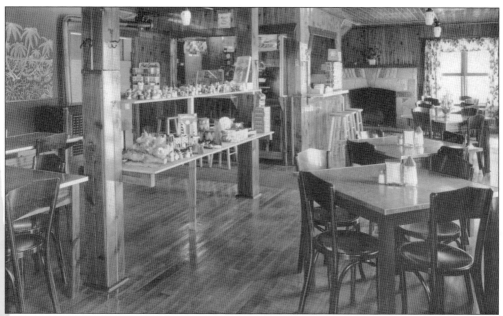

This interior view of Van's Tower Restaurant shows a couple of shelves devoted to souvenirs. Just about every roadside business, regardless of its nature, sold curios in the first 50 years of Osage Beach history. The tower and hotel building survived to the early 1960s. Nothing is left today to indicate they ever existed except in real-photograph postcards.

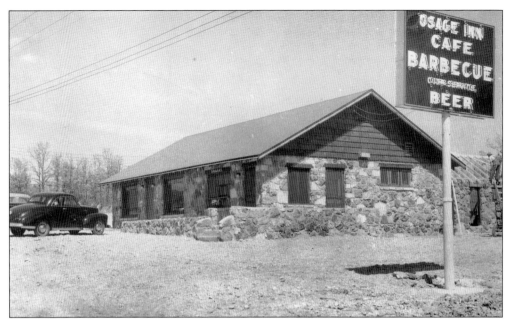

Two popular eating establishments at the lake in the 1940s were the Ozark Inn Café in Lake Ozark and the Osage Inn Café in Osage Beach. Tourists were sometimes confused because of the similarity in their names. The Osage Inn Café was located on the corner of Jayhawk Street and Osage Beach Parkway. The café opened in the late 1940s.

The owners of the Osage Inn Café were Mr. and Mrs. Larry Geber. The café had this addition by the end of the 1940s, but on July 4, 1950, it caught fire and burned to the ground. The origin of the fire was never determined. The rock building sitting at this location today is, therefore, not the original building.

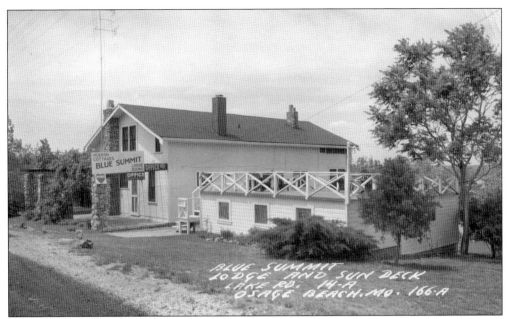

The Blue Summit Lodge was once located along Lighthouse Road (originally Lake Road 14A), which was later divided into Lighthouse Road and Red Bud Road. The resort advertised to fishermen and hunters and also had fishing guides available. The resort opened in the 1930s and closed around 1970. The site is heavily developed today.

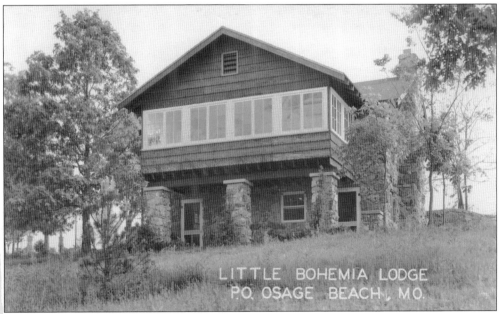

Little Bohemia Lodge, once on Lighthouse Road, was open from 1937 to 1944, when it was sold and became Lake Lawn Lodge. The naming of the Little Bohemia Lodge is a mystery. Was there a connection, however remote, between it and the famed Little Bohemia Lodge of Manitowish Waters, Wisconsin, scene of the famous Dillinger Gang–FBI shootout on April 23, 1934?

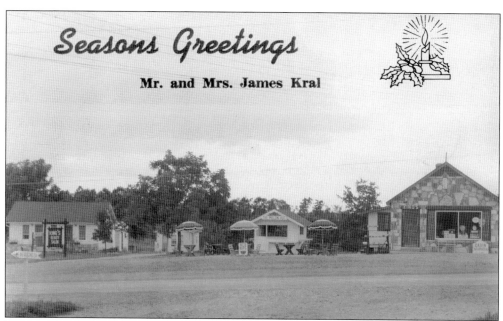

James and Mary Kral opened three businesses in Osage Beach in the 1940s: King's Beauty Salon (left), the Melon Hut (center), and King's Sundries, shown here on their 1949 Christmas card that was sent to friends and family. The salon and melon hut property is now a part of the parking lot for a Shoney's restaurant. The Krals later built Kings Plaza Shopping Center.

Lake Lawn Lodge was originally called Little Bohemia Lodge. The people who purchased it in the 1940s enlarged the resort and built more cabins. This resort appears to have ceased operation under the name Lake Lawn Lodge in the mid-1970s and may have been sold and reopened as Dragon Lake Resort, which operated for only a few years.

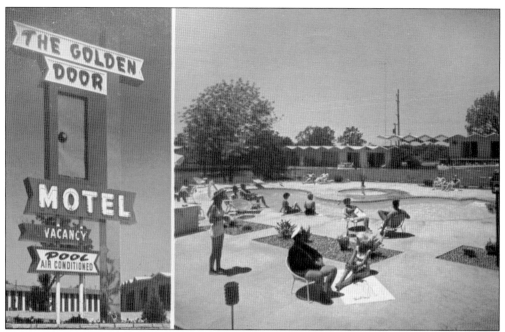

The Golden Door Motel, adjacent to Jayhawk Street (originally Passover Road), was new in 1965. Charles and Ila McQuillen were the proprietors in the 1960s. The gold-colored door in their sign continually rotates, its golden sheen flashing to catch the eye. The motel's slogan when it opened was, "your golden door to a wonderful vacation."

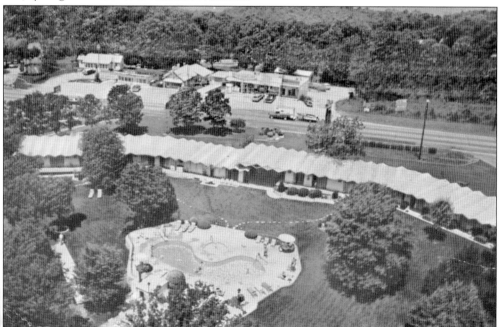

The units at the Golden Door Motel are attached and form a gentle arc facing the highway. Across the highway in this 1960s photograph was King's Sundries and Liquor, Quick Shop Market, and some professional offices. Today, the backyard of the motel is adjacent to the Osage Beach Premium Outlet Mall, the lake area's largest shopping center with 110 stores.

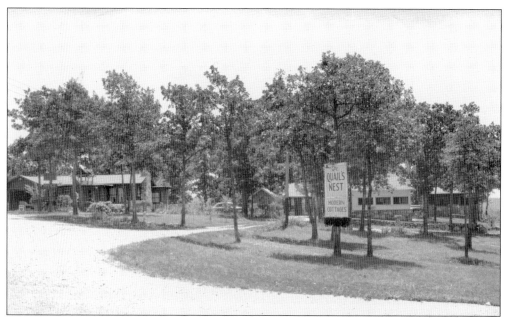

The Quail's Nest has a history dating to the 1940s and resulted from Edward and Lottie Hyde adding enough rooms onto their home to create rental rooms. They named it "Quail's Nest" because of their love of nature, yet achieved something almost unique. Among the more than 1,000 resorts at the lake, past and present, few of their names start with the letter "Q."

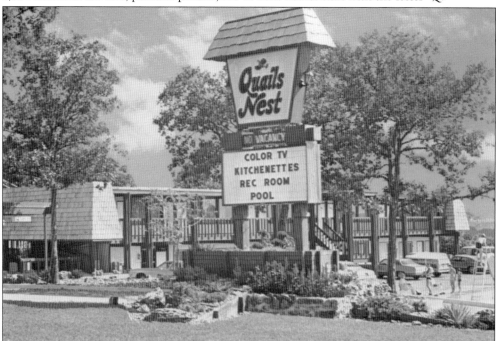

In 1975, Don and Debbie Welch purchased the Quail's Nest. Shown is a view from 1978. Recent renovations and additions to the lodge have given the establishment a very classy look. The business is still in operation just west of the Osage Beach Premium Outlet Mall. Don's parents once owned and operated a resort in Lake Ozark.

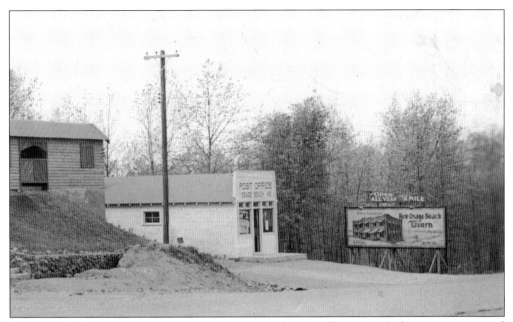

When the Zebra post office became the Osage Beach post office in 1935, the operation moved to this building, which faces the entrance to Osage Beach Road (Lake Road 54-24). The post office outgrew this building by the beginning of the 1960s and moved across the highway to the building formerly used by Folded Hills Dining Room.

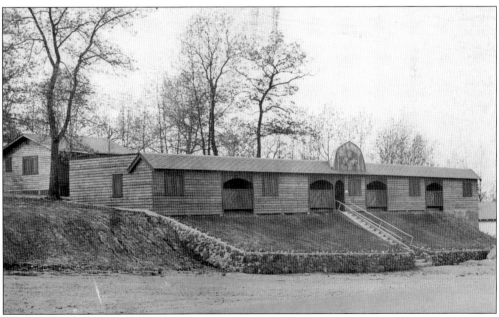

Idlewild Court sat adjacent to the Osage Beach post office, pictured in the top photograph. Idlewild was built in 1936 and looked like a log fort. Guests drove around to the back of the building to park and enter their units. Lee Gunnison was the original owner. By 1968, it was owned by George and Vi Strickland, who also owned the Texaco gas station nearby.

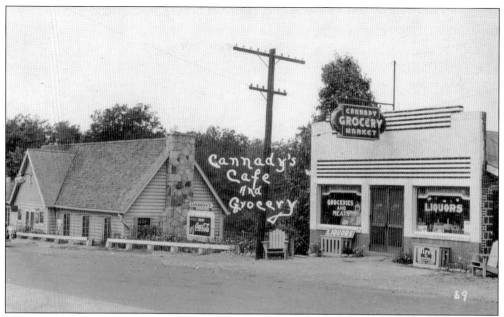

Most of the 240 acres that belonged to the Osage Development Company (see advertisement on page 19) was along the lake on either side of Osage Beach Road. Just a sliver of company acreage crossed the Osage Beach Parkway, but it was here that Mrs. A.B. Cannady and her husband bought land in 1933 and built their café and grocery.

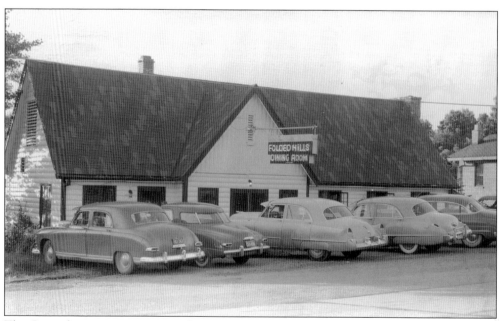

The Cannadys were very active with the Lake of the Ozarks Association and often hosted the organization's meetings in their café. They sold it in the 1940s to Dot and Harvey Garvey, and the Garveys renamed it the Folded Hills Dining Room. The Garveys sold the building about 1960. It was then remodeled and given a brick exterior.

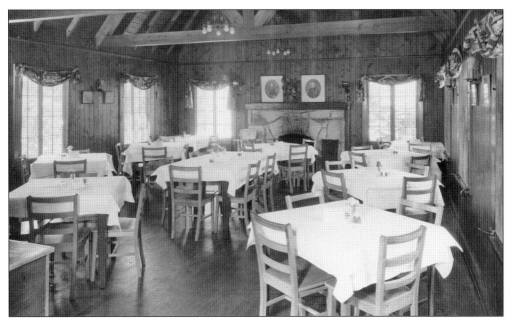

The interior of the Folded Hills Dining Room was paneled with knotty pine. Sitting as the café did at the junction of Osage Beach Road and the highway, business was good. It was, at the time, one of the busiest lake roads in Osage Beach. Kirkwood Lodge and the Osage Beach Hotel were both on the lake road.

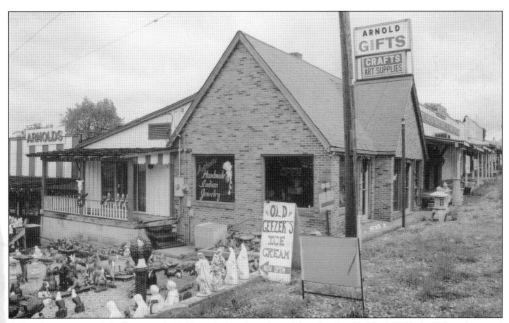

After being remodeled around 1960 and faced with red brick, the Folded Hills building housed the Osage Beach post office for a number of years. The post office eventually moved farther west along Osage Beach Parkway. This building then housed Arnold's Country Corner until it was demolished about 2005. The lot is currently vacant.

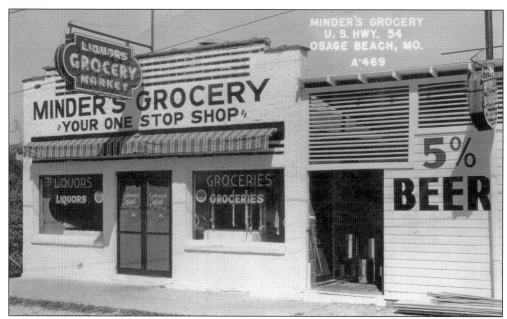

Minder's Grocery was previously the Cannady Grocery and sat on the east side of Cannady's Café. In the late 1940s, the Cannadys sold the store to Melvin Minder, who renamed the business and added a storeroom. Melvin's wife and Mrs. Cannady were sisters. Minder's Grocery was in business until about 1969. This building no longer exists.

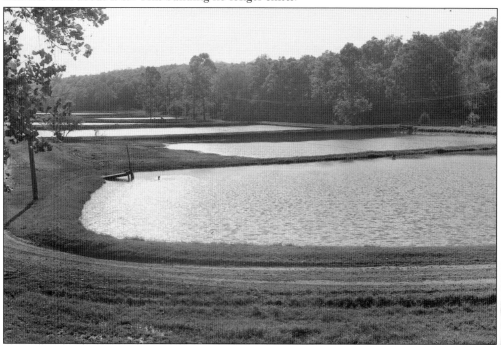

When Bagnell Dam was built across the Osage River, no fish ladders were installed. To compensate, Union Electric built the Grand Glaize Fish Hatchery, often called the Zebra Hatchery, in Osage Beach to stock Lake of the Ozarks with game fish. Today, these ponds are gone, and this location is a city park. (Courtesy of the Missouri State Archives.)

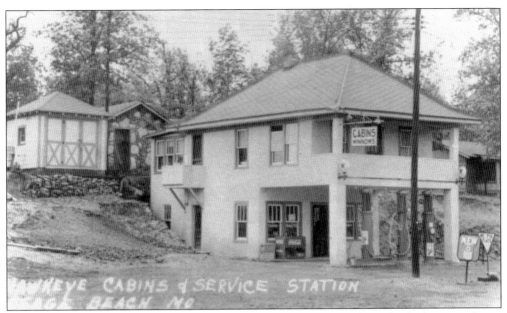

The Hawkeye Cabins and Service Station made its appearance along the highway in Osage Beach around 1947. The business was east of Osage Beach Road on the south side of the highway. The proprietor was Harry Greer. His Texaco station would become Brockway's in the 1950s and Strickland's in the late 1960s.

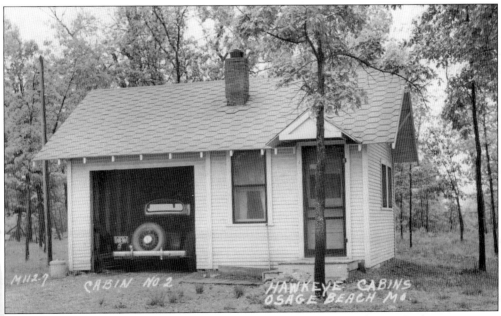

It would be interesting to know how Greer came to call his place "Hawkeye." Hawks are common in the lake area, and there are several species. There is also an old town site east of Osage Beach on the Miller-Pulaski county line on U Road that was once called Hawkeye. The Hawkeye post office functioned from 1882 to 1955.

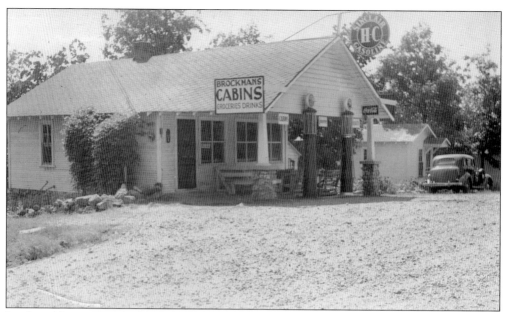

In the early years, with development hampered by the Great Depression and World War II rationing, many camps sold gas and groceries to their guests. Brockman's Camp had one of the earliest camp convenience stores in Osage Beach. His camp was located on Osage Beach Road not far from Kirkwood Lodge.

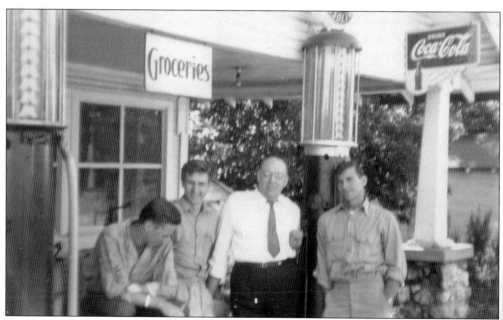

Brockman of Brockman's Camp is pictured here in the white shirt with fellows who probably worked for him. He sold Sinclair gas dispensed from gravity gas pumps with visible cylinders on top. Gas was hand-pumped into the cylinder, which would hold 10 or 12 gallons, and then gravity-fed into a car's tank. These pumps were phased out in the 1940s.

Canopies at gas stations are usually added to protect customers from inclement weather. At Brockman's Camp, the canopied area often served as a gathering place for locals to socialize and observe the tourists who bought gas during the summer. One fellow above appears to be reading the newspaper, which was another source of material for conversations.

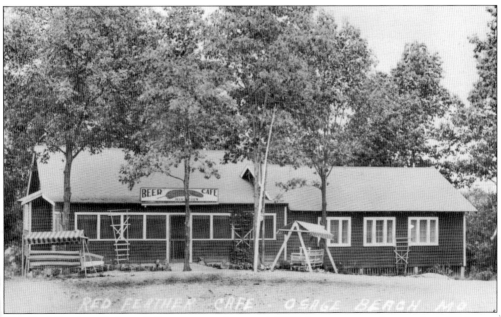

The Red Feather Café and Camp opened around 1935. It was across from today's Walmart. Originally, it was just one small building, but an addition came a few years later to accommodate a second dining room. The café specialized in country ham and smoked barbecue. After a time, the café moved to another building a few hundred yards west.

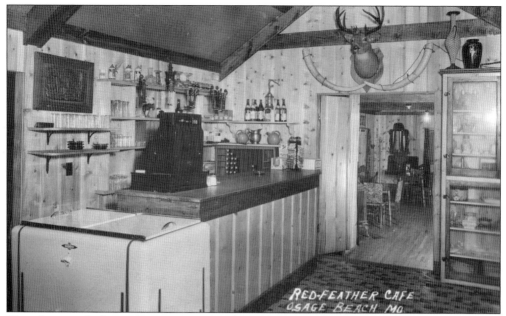

This photograph shows the main entry at the Red Feather Café and the original dining room straight ahead. The addition to the building was accessible to the right. The entire establishment was paneled in knotty pine. Its new location eventually became Jo Jo's Restaurant, which today is the 1950s-themed 54 Diner.

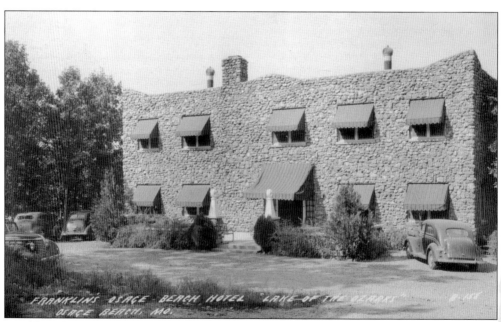

Franklin's Osage Beach Hotel, located on Osage Beach Road, was built between 1931 and 1932 by B. Ray Franklin and is still standing. The 23-room hotel has cobblestone veneer, but only on the front and sides of the building. Franklin died in the mid-1930s, and his wife continued the hotel operation until she sold it in 1946 to the Bruner family of St. Louis.

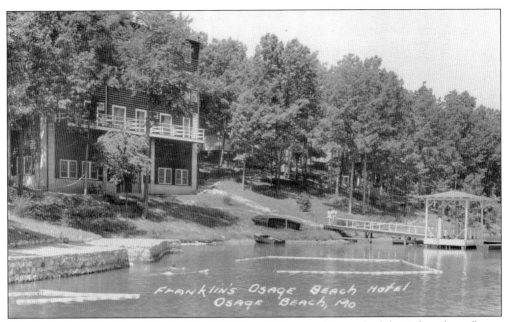

The backside of the Osage Beach Hotel building is frame and faces the lake. It has three floors, and the entry doors on the bottom level are large enough for a good-sized boat to be brought into the building. Franklin had a marine railway installed for storing a boat inside during the winter months.

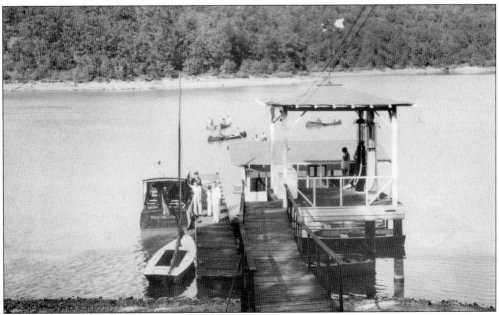

The Osage Beach Hotel had an interesting boat dock with two visible gas pumps under the roof. The hotel maintained rowboats and speedboats as well as a powerful Chris Craft cruiser, which guests could rent for $5 per day plus the cost of gas. The Osage Beach Hotel closed around 1960 and has been a private residence ever since.

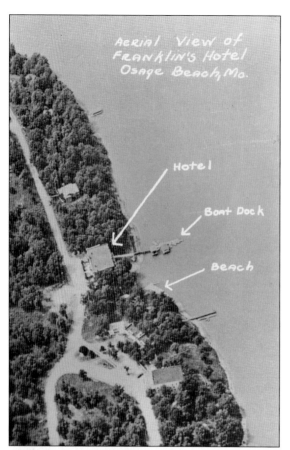

Aerial View of
Franklin's Hotel
Osage Beach, Mo.

Hotel

Boat Dock

Beach

This view of the Osage Beach Hotel shows not only the hotel's boat dock and beach, but also the area just south of the hotel, where the property joined that of Arthur M. Pope. In the early 1940s, Pope sold his own hotel business to retired Army colonels Lawrence Kirkman and John D. Woodmansee.

Kirkman and Woodmansee, who purchased the Arthur Pope Hotel, combined portions of their names to christen their new business "Kirkwood Lodge." They did not keep it very long. In 1944, they sold to Dr. A.J. Amick, who had a boat business in the cove. In 1946, Amick leased the lodge to Bill Hagadorn with an option to buy.

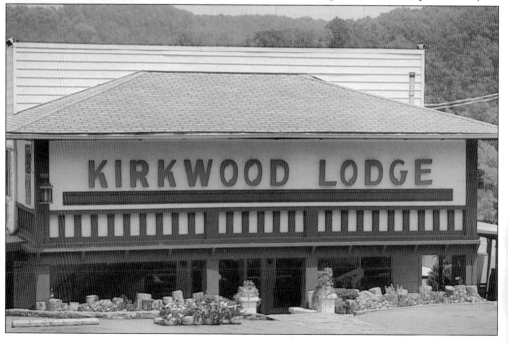

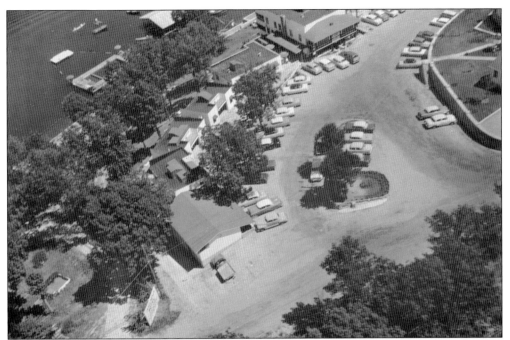

Bill Hagadorn's parents immediately joined the operation, and they quickly exercised the option to buy Kirkwood Lodge. Innovative and progressive, the Hagadorns had a lot of ideas about how to expand the business. One of those ideas was to start a square dance school at the resort. Above is a mid-1950s view of the Kirkwood units and parking lot.

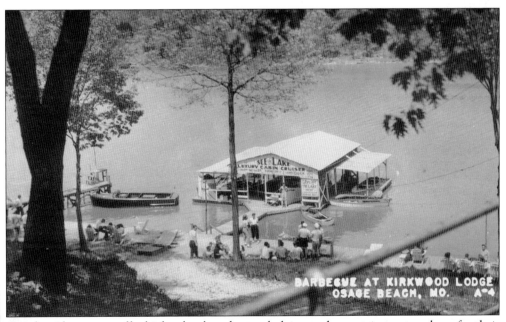

Another idea was to offer high school students a lodging and entertainment package for their senior trip. Kirkwood Lodge enlisted the cooperation of neighboring resorts and pitched its offer to schools in states that bordered Missouri and from where most of the lake's summer visitors came. It turned out to be a very successful and profitable enterprise.

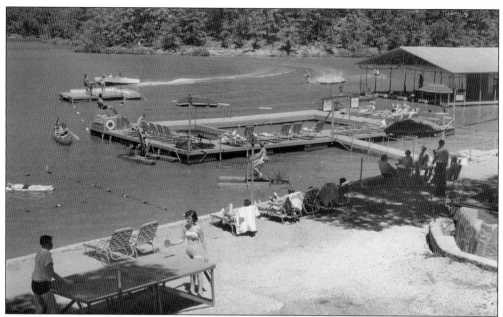

The students would stay at Kirkwood Lodge for three or four days. Entertainment could include any combination of dances, lake cruises, trail rides, country music shows, cave tours, and other activities. This photograph shows the lakefront at Kirkwood in the 1950s and 1960s. (Courtesy of the Missouri State Archives.)

What truly put Kirkwood Lodge on the map in the Midwest was square dancing. This 1950s photograph shows the famed California square dance caller Les Gotcher (far left) and Bill Hagadorn (far right) at Kirkwood. Gotcher organized the resort's square dance institute (see chapter four). (Courtesy of Sue Dutton.)

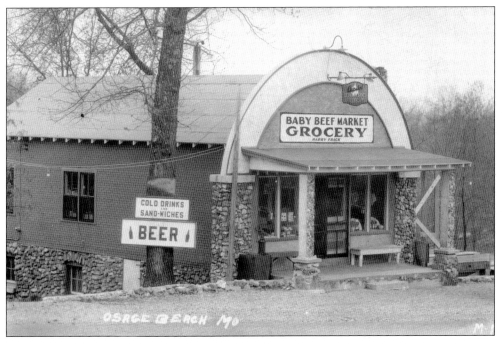

The Baby Beef Market was one of the largest grocery stores to open in Osage Beach in the 1930s and was located about a half-mile east of Osage Beach Road on the south side of the highway. It was the first building constructed by Harry Frack, who also built Frack's Acre. Glen Cromer managed the grocery store.

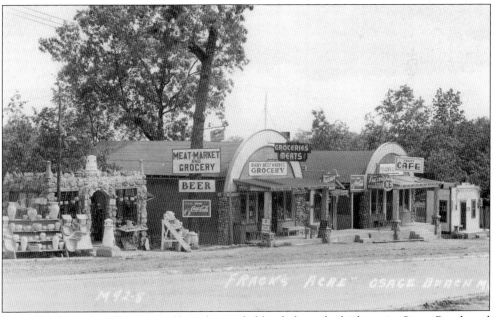

Harry Frack purchased an acre of heavily wooded land along the highway in Osage Beach and announced that he was going to put as many businesses on that one acre as possible. His collection of buildings and shops became the first strip mall in Osage Beach history. People said he would go broke, but he proved them wrong.

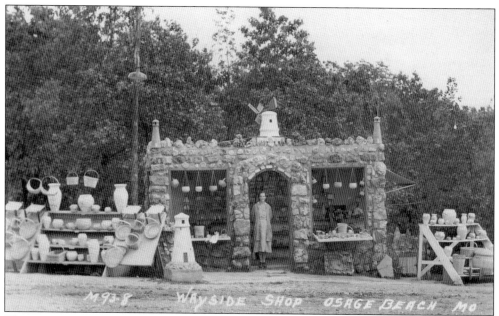

The most unusual building in Frack's Acre was the Wayside Shoppe, shown above. Francis Cromer, who managed the little gift shop, is standing in the doorway. The Cromers and Fracks were related. The building was constructed entirely out of native rock, but who actually built it has not been determined. These buildings stood until the 1960s.

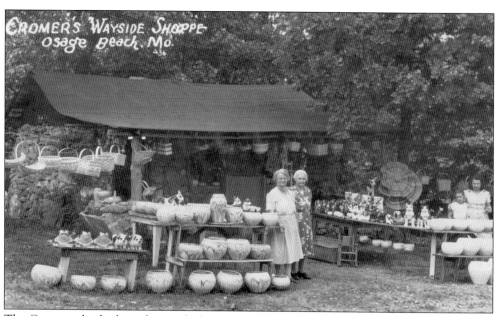

The Cromers also had another roadside shop, and two of the Cromer women can be seen here. The Cromers were potters and made most of the colorful Ozark pottery they sold. Some other gift shops in the area also sold their products. These pottery shops and Frack's Acre were close to where Walmart is located today.

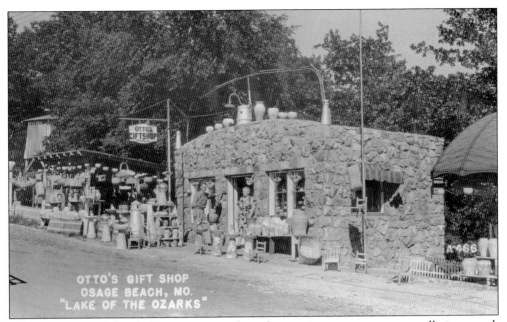

Francis Cromer's Wayside Shoppe, pictured on the previous page, was eventually improved, getting an arched roof, better windows, and a doorway. It was leased and became Otto's Gift Shop. Miniature lighthouses were popular novelty items in the Cromer shops, and it is apparent that Otto continued to sell them.

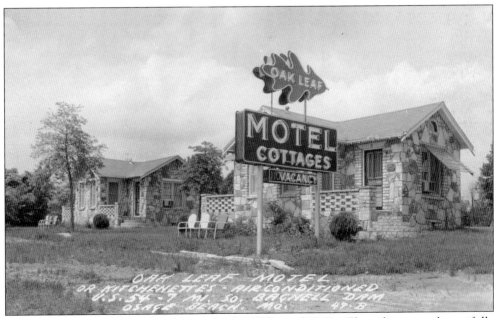

The Oak Leaf Motel was in operation in the 1950s and 1960s. The cabins were beautifully constructed with classic rockwork. Not much is known about the early stonemasons who built these handsome rock cottages at the lake in the early decades. The people who owned the motel also owned the Oak Leaf Resort on the lake.

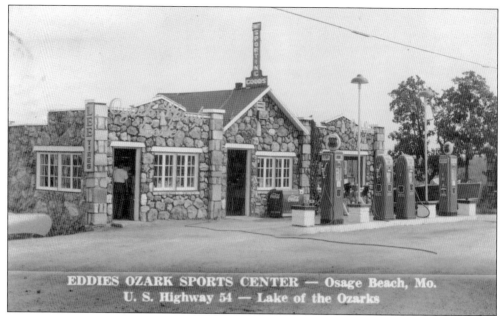

EDDIES OZARK SPORTS CENTER — Osage Beach, Mo.
U. S. Highway 54 — Lake of the Ozarks

Eddie's Ozark Sports Center, with its attractive architecture, was a combined sports shop, gas station, and minnow shop in the 1940s, 1950s, and early 1960s. At night, it lit up along the highway with bright neon that gave the rockwork distinction. The business also operated a charter boat on the lake known as the *Betty Bee*.

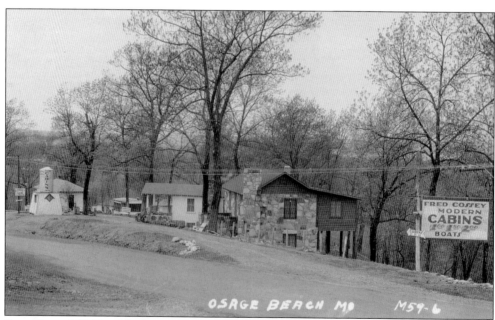

From the mid-1940s to the late 1950s, Fred Cossey's Camp sat along Osage Beach Parkway across the road from today's Walmart. Between Kay's Restaurant and Walmart stood Powell's Supreme View Camp; the driveway at the west end of Powell's can be seen in the lower left. Cossey's Camp also had a popular fishing barge in Kirkwood Lodge cove.

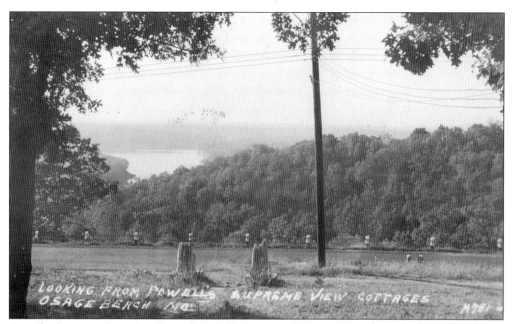

On a high point along the Osage Beach Parkway—where it passes through Osage Beach—is this grand view, which gave Powell's Supreme View Cottages their name. The tips of two sizable stalactites, placed upside down, served as corner posts for the original walkway. It is said they came from one of the many caves in the lake region.

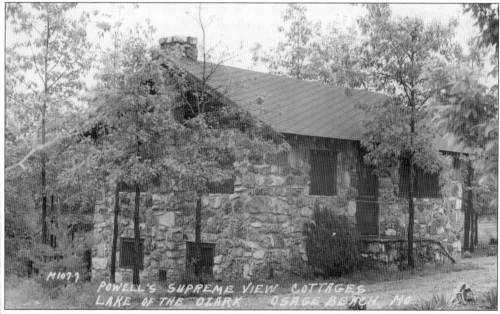

The rock cottages of Powell's Resort also contained embedded cave formations. Missouri caves are protected today through the Missouri Cave Protection Act, which prohibits the breaking and removal of cave formations. Powell's Supreme View Cottages sat on what is today the parking lot for the Walmart in Osage Beach.

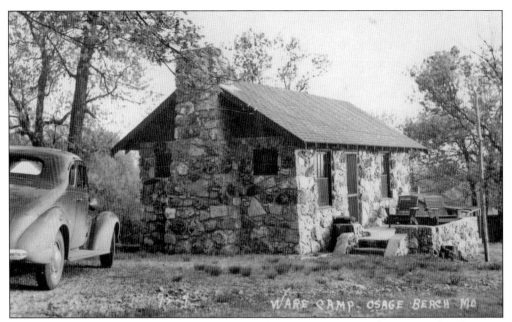

Ware's Camp, once adjacent to Powell's Supreme View Cottages, opened in 1932. Already senior citizens when they opened the camp, Harry and Ella Ware found it tough going. Harry died in a car accident in 1936, and Ella sold the resort in 1939. It is thought that the Powells bought the resort and merged it with their own.

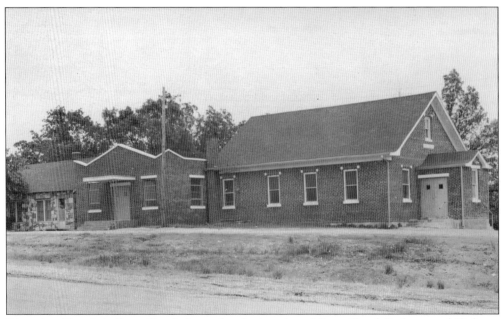

Riverview Church in Osage Beach, located at the junction of Osage Beach Parkway and Highway 42, has neither a view of a river nor of the lake. The church was organized in 1887 and originally sat on a hill overlooking the Osage River. The building was relocated when the lake was formed and has seen extensive enlargement since this photograph was taken.

Three

BRIDGEPORT TO THE PALISADES

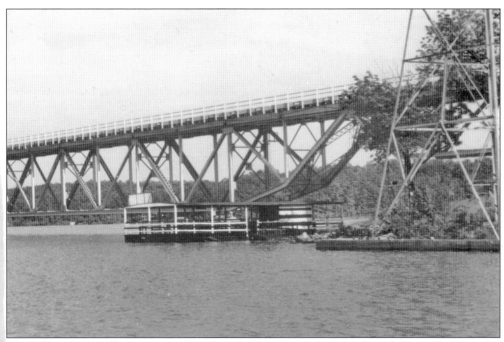

The Jeffries Fishing Barge was anchored to the shore just below the Grand Glaize Bridge at the west end (on the north side) from the 1930s to the 1960s. To reach the barge, one could follow a narrow road that led along the cove's shoreline next to a high concrete retaining wall, which held back the steep slope going up to the highway's edge.

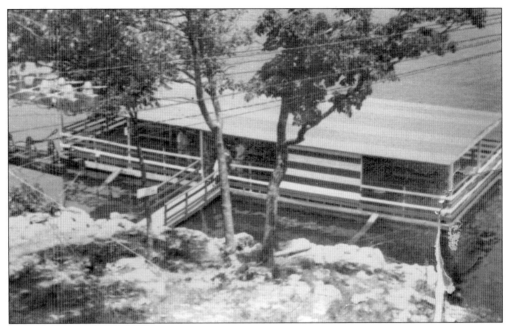

Three women of the family—Valonia, Wilma, and Nellie Jeffries—managed the Jeffries Fishing Barge. Fishing near the bridge was especially good and encouraged other fishermen to anchor commercial barges to or near piers of the bridge, creating a bad situation that soon got out of hand. (Courtesy of Dale Jeffries.)

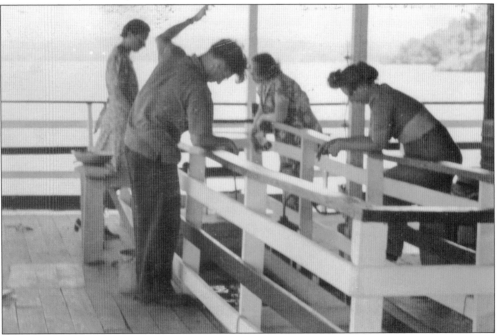

The fishermen with their unsafe, unsanitary barges soon found themselves in trouble with the Missouri State Highway Department and the Missouri attorney general and had to relocate. Fortunately, the Jeffries family owned the shoreline property to which they were anchored and came out of the fracas unscathed. (Courtesy of Dale Jeffries.)

This early 1930s photograph of the Jeffries land north of the highway at the west end of the Grand Glaize Bridge was taken before the Fishing Barge was established. The road to the barge ran along the lower part of the slope toward the utility tower. This land has since been obliterated with fill for the Highway 54 Expressway.

The sons of William Derrick Jeffries—Tolliver, Frank, and Leland—operated the Jeffries Boat Dock. On tourist maps and in publications, these businesses were generally promoted as Jeffries Camp and Fishing Barge or Jeffries Camp and Boat Dock. The Jeffries family also had rental cottages along Jeffries Road about 800 feet west of the bridge.

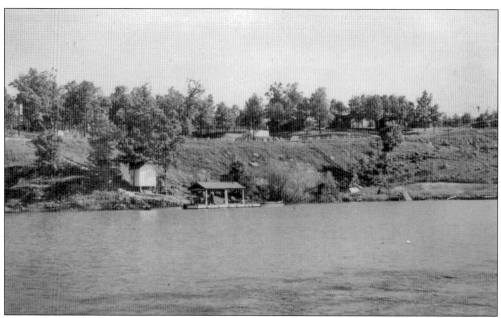

The Jeffries Boat Dock is pictured as seen from across the cove in a photograph taken before the road to the Fishing Barge was built. The Grand Glaize Bridge is to the left and the Grand Glaize Café is to the right. On the hill along the highway is Barber's Resort. The entire shoreline shown here was recently buried in dirt and rock fill base for the new Highway 54 Expressway.

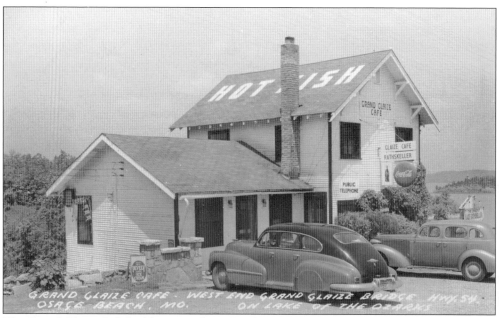

The Grand Glaize Café building was about 500 feet west of the bridge on the Jeffries land. The café opened for business around 1940 and was often called the Hot Fish Café because of the letters painted on the roof. Alta Monte ran the café, and Roy Jeffries operated the Cool Spot Rathskeller, a basement-level tavern.

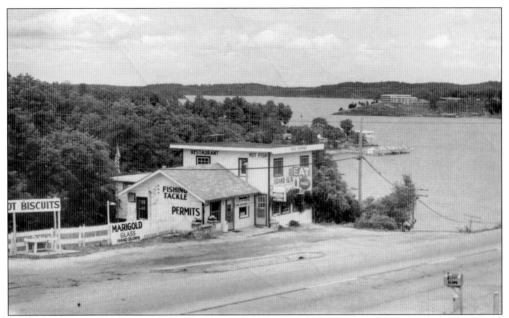

By the 1970s, the Grand Glaize Café had traded its gable roof for a flat one. In 1976, the café was sold to Joseph H. Boer, a chef, who renamed it the Potted Steer. During construction for the Highway 54 Expressway, the Potted Steer was not open. The building on the point in the background is the Mai-Tai Resort building, which replaced the Pla-Port Lighthouse.

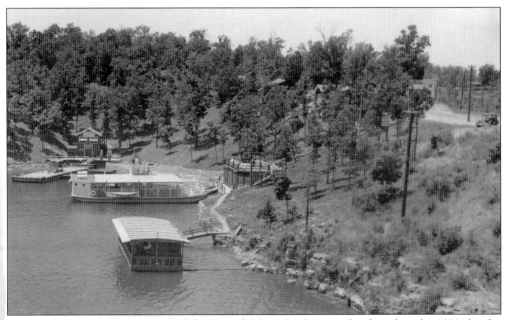

The south side on the west end of the Grand Glaize Bridge was developed in the 1930s by the Lake Amusement Company, which established an excursion boat business. The *Gov. McClurg* excursion boat is seen at the dock. The boat was new when this photograph was taken. Frank Miles was the excursion boat captain.

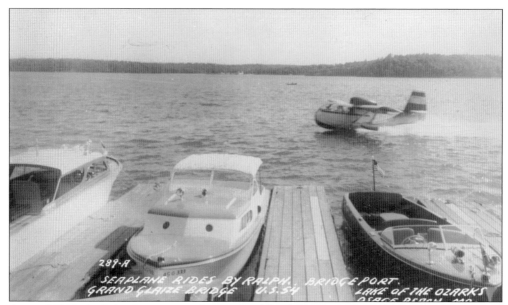

Around 1940, the Lake Amusement Company sold its business on the south side at the west end of the bridge and it became Bridgeport. The owner expanded the facilities. Bridgeport was still the homeport of the *Gov. McClurg*, and W.W. Gore was captain. The boat would run excursions here until the early 1960s.

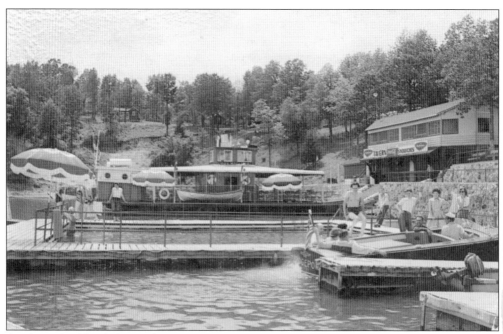

As the 1950s blended into the 1960s, the lakefront at Bridgeport became more crowded with development, and the business became known as Churchill's Bridgeport. In the background is the *Gov. McClurg*. The floating swimming pool, which was open to the public, was between the excursion boat and the speedboat docks.

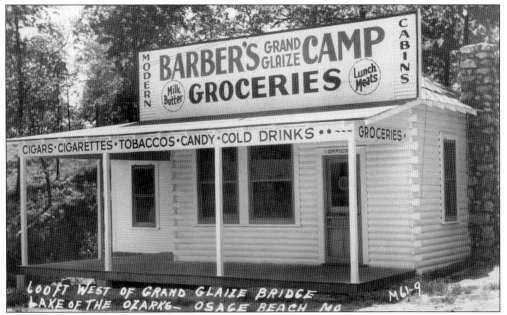

Barber's Grand Glaize Camp was adjacent to Bridgeport on the west when Bridgeport was an operation of the Lake Amusement Company. The camp remained Barber's for only a few years before it was sold and became Bond's Grand Glaize Camp. This attractive office building, which served several purposes, was close to the highway.

Bond did not change the architectural style of the cabins, although the camp's brochure was less sophisticated than the one produced by Barber. The camp had log, rock, and frame cabins, and some were a combination of all three. There was a floating swimming pool on the lake and rowboats rented for $1 per day.

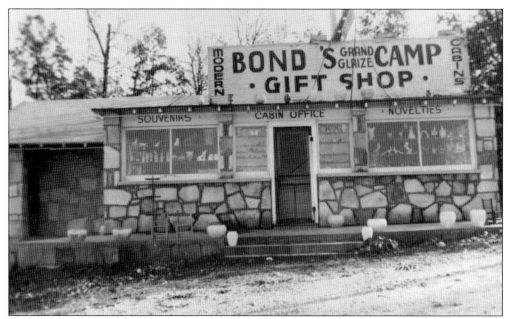

The exterior of Bond's roadside gift shop was a little out of character with the style of other buildings at the camp. The style was indigenous to the region and was known as "giraffe rock," which was common in the Missouri and Arkansas Ozarks from the 1920s to the 1950s. The sandstone slabs were set vertically and often had raised mortar between them.

Altogether, Bond's Camp had 15 units, and the interiors of the cabins were paneled in knotty pine. The cabins all had the same floor plan with two to three bedrooms, a kitchenette, and a bath. They had refrigerators and tabletop gas ranges. Guest rates ranged from $6 to $12 per day.

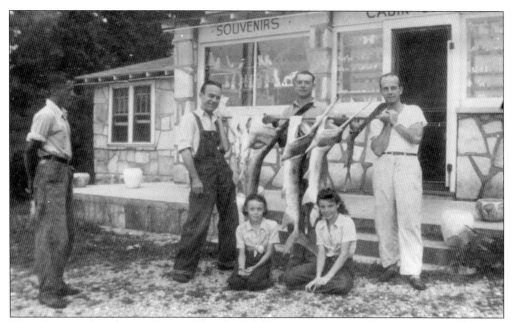

This photograph, taken in front of Bond's Gift Shop, is interesting for two reasons. The men display spoonbill (paddlefish), an Osage River fish that resembles a shark and is usually taken with a net or a trap. The photograph also shows a young black man. African Americans were generally not welcome at the lake until the late 1960s.

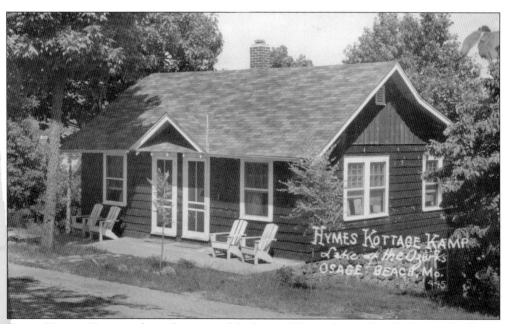

Hymes Kottage Kamp, with its clever use of the letter "K," was close to Bond's Camp. Charles M. and Hazel Hymes opened it in 1936. They were the parents of Chet Mason Hymes, who owned Chet's Anchor Inn (see page 20). The Hymes also had a second camp they called Hymes Kottage Kamp No. 2 near the end of Jeffries Road.

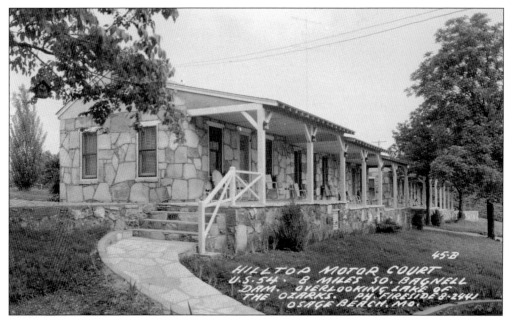

The Hilltop Motor Court, originally called the Hilltop Cottages and later the Hilltop Motel, was established in 1950 and stood on the hill just west of the Grand Glaize Café. In the late 1950s, these units were completely renovated and a second story was added. Today, a bridge on Jeffries Road spanning the new Highway 54 Expressway occupies this property.

Idle Days Resort opened in 1951 and once faced the Osage Beach Parkway from across a cove behind the Grand Glaize Café. A companion operation, known as the Gala Resort, was built behind the property. The Highway 54 Expressway took most of this property, which had extensive rock retaining walls.

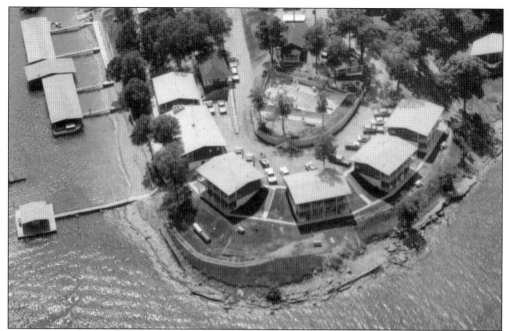

From the Grand Glaize Bridge to the confluence of the Glaize and Osage Rivers, it is three quarters of a mile. Four peninsulas extend out into the lake along the west side. Until recently, Point Breeze Resort occupied one of the points; this view shows how the resort covered the point in the 1960s.

Silver King Resort once faced the Grand Glaize Bridge from a peninsula on the west side of the Grand Glaize Arm. Fred Goodin established the resort in 1948 and sold it to J.O. Cardwell (waving at the camera) in 1952. J.O. renamed it Silver King, after the vacuum cleaners he sold for many years.

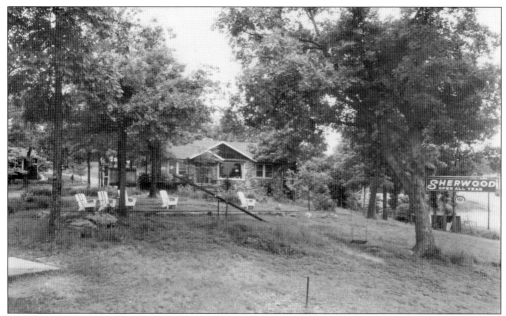

Charles Hymes died in 1948, and the Hymes Kottage Kamp No. 1 was sold. The new owners renamed it Sherwood Resort. In the 1950s and 1960s, the Sherwood development would transform the appearance of the hillside as it expanded, eventually including a roadside restaurant and the resort on the hillside.

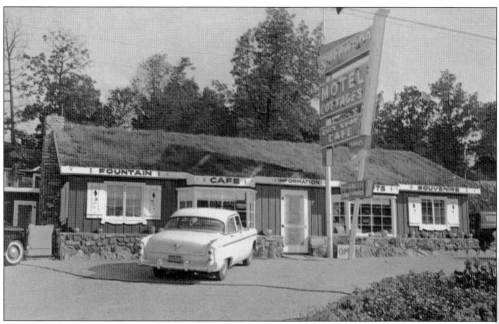

A café preceded the restaurant, and the building hosted the resort office and a gift shop. The building had a green sod roof, which was unusual for the lake area. At this time, Clara and George Haar operated the Sherwood Resort and Motel. Their slogan was, "welcome to a bit of Denmark."

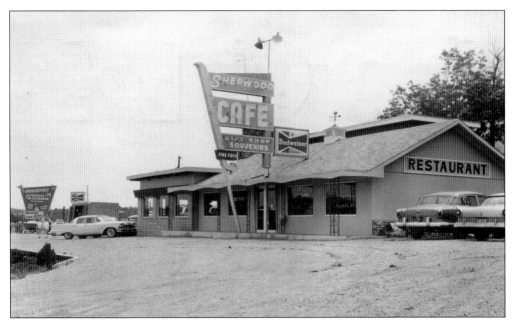

By the 1960s, the Sherwood Café building had undergone a complete transformation and was called the Sherwood Restaurant. In the background is the entry and parking lot for Bridgeport with a small building beneath the sign where they promoted Bridgeport and provided resort information. Sherwood Restaurant had a commanding presence at its location.

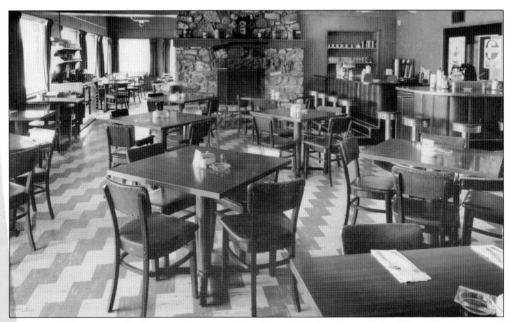

Sherwood Restaurant had a superb view of the Grand Glaize Arm of the lake. The interior of the restaurant had a high, open-beam ceiling and a fireplace. When this photograph was taken, the chair seats and backs were red. A 16-ounce T-bone steak cost $3.95. The menu also offered Danish specials, such as *Danske frikadeller med rod kaal* (Danish meatballs with red cabbage).

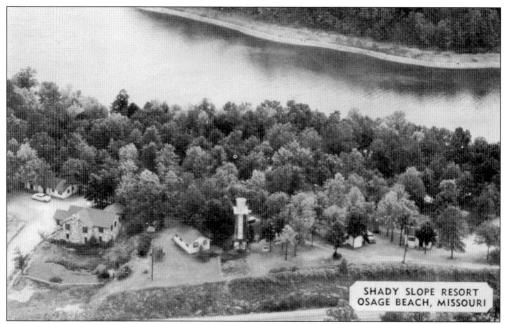

SHADY SLOPE RESORT
OSAGE BEACH, MISSOURI

Sherwood Resort's neighbor to the west was Shady Slope Resort, built in 1932 by Dan D. Dudley. This view shows the highway, the narrow stretch of land upon which the resort was built, and a lake cove. The resort's water system had a water tank on a steel tower perched on the well house.

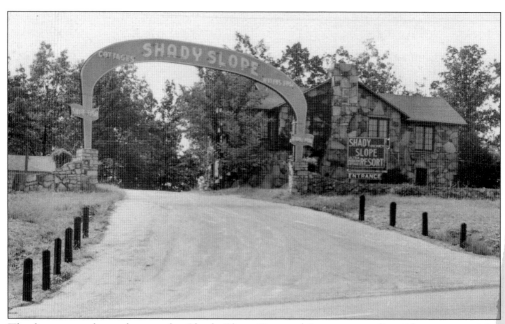

The letters on the arch over the Shady Slope Resort driveway were lit with neon at night. The large house was Dudley's home and also served as an office. This house stood until the beginning of the 21st century, but is now gone. The archway vanished well before Shady Slope Resort was dismantled.

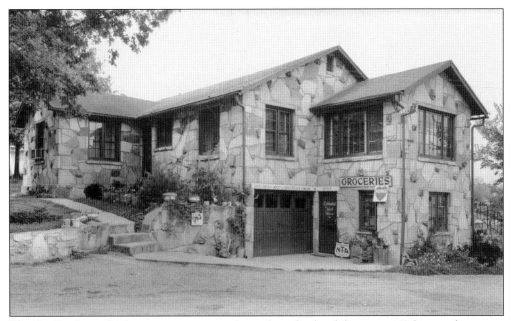

The Dudley home had a grocery store on the parking lot level for guests. Cabins and cottages at most resorts from 1931 to 1961 had kitchenettes so that guests could cook their meals rather than go out to cafes and restaurants. The grocery store also earned extra income for the resort owners. Shady Slope Resort changed owners several times in its lifetime.

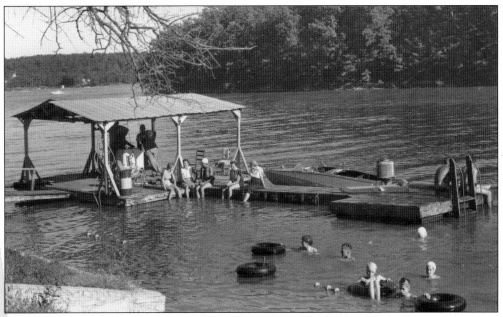

A lazy summer day shows some guests enjoying a swim in the lake at Shady Slope, while others sit on the dock to socialize and soak their feet. The shoreline on the south side of this cove showed no development when this photograph was taken. Shady Slope Resort was replaced by Lake Chateau Resort Inn in 1976.

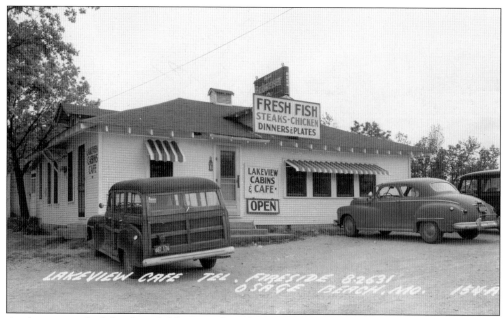

At the west end of the Grand Glaize Bridge, the Osage Beach Parkway goes up a long hill. At the crest on the south side during the 1950s and 1960s was the Lakeview Café. The café was established around 1935 by Robert Jeffries and was then known as the Ozark Café. As it changed owners, it changed names.

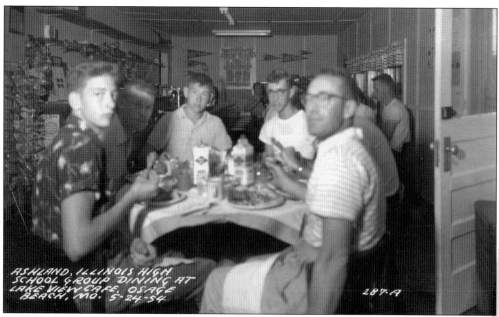

After being the Ozark Café, it became known as Turin's Café, Neely's Café, and finally Lakeview Café in 1953. In the 1950s and 1960s, resorts west of the bridge catered to students on their high school senior trips. A group of students are pictured here in the Lakeview Café. Note the pennants on the back wall. The café also sold a few souvenirs.

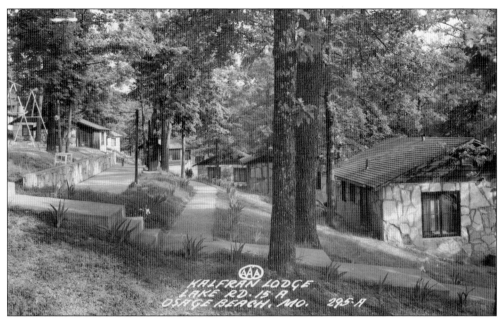

Kalfran Lodge opened in 1948 off Lake Road 15A, now Jeffries Road. "Kal" was the nickname of K.K. Schopp, who built the resort. Kal and his wife, Gladys, ran the resort until their divorce in 1958. In 1960, Gladys traded the resort business to Dick Jasinsky for Lakeside Court in Lake Ozark, Missouri.

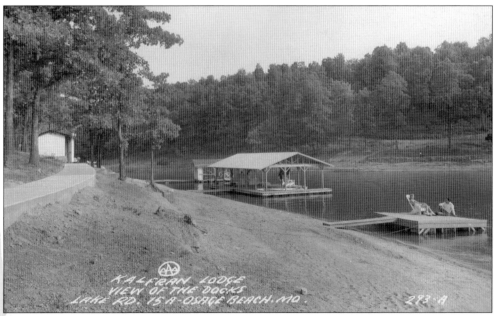

The Kalfran Lodge property wraps around the head of a cove, and in the late 1940s and early 1950s, the development of swimming and boating facilities was modest. As time passed, the property became heavily developed. Note that the shoreline in the background of this photograph is manicured, but undeveloped. The following photograph shows it later.

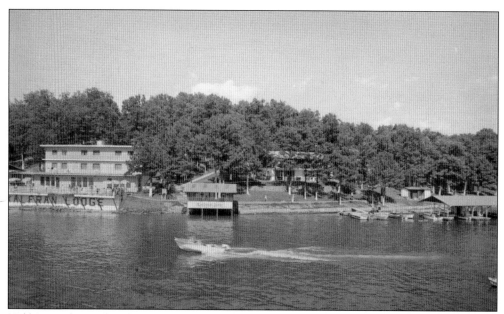

Kalfran Lodge still had a few rock cottages by 1970, but newer guest housing reflected more modern architecture. By 1980, the resort had 50 units and two swimming pools. Since then, accommodations have morphed into condominiums. In the 1950s and 1960s, Kalfran Resort was one of the resorts that catered to high school students on senior trips.

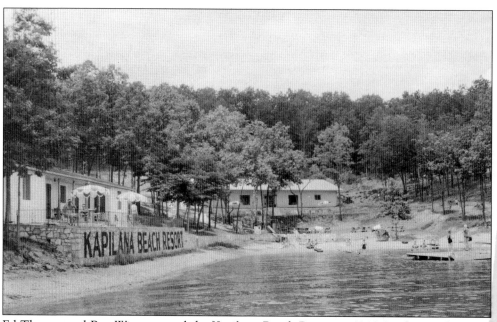

Ed Thomas and Ray Winn opened the Kapilana Beach Resort in 1946. It advertised as "one of the better resorts." The resort, now a condominium complex, expanded rapidly and built an extensive sand beach, which was emphasized as "for registered guests only." By the 1950s, their slogan was "your fun headquarters."

This 1959 photograph shows lakeside units at Kapilana Beach Resort. By 1961, the resort had more than 20 units and kept expanding, offering its guests vacation packages that included movies, beach parties, and cruises on the lake. It was also one of the Osage Beach resorts that catered to high school students on their senior trips in the spring.

In the 1950s, 1960s, and 1970s, thousands of students from other states came to Lake of the Ozarks on their senior trips. These students were staying at Kapilana Beach Resort. Insurance and economic problems began to curtail this practice by the 1980s, as many schools quit allowing their buses and students to be taken out of state for senior trips.

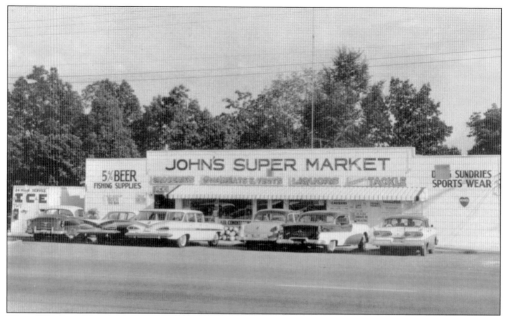

This grocery store first opened as Draper's Grocery in 1944 and then became Clark's Market. John Laurie bought it in 1947. He was a native of "old" Linn Creek, born there in 1918. Laurie had the store until 1963, when he sold to "Dolph" Ezard. In 1968, Dolph sold to his son Bill. This building has been remodeled and is still standing, but at present does not house a grocery.

Grand Glaize Standard appeared along the Osage Beach Parkway in 1946 and was located about a half mile west of the bridge. It was known as Medford's Glaize Standard at one time and then as the Glaize Standard Service and Gift Shop in the 1950s. In the 1960s and 1970s, it was the Smith Standard, operated by Wilbur Smith, who passed it on to his son Roger.

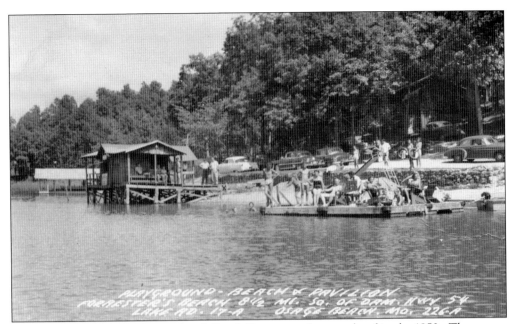

Pictured is the waterfront at Forrester's Beach Resort on a busy weekend in the 1950s. The owner, Thomas "Tommy" Forrester, was a prominent architect at the lake from the 1930s to the 1960s. He designed and supervised the construction of the Pla-Port Lighthouse in Osage Beach as well as many rock and log homes and resort cottages.

The cottages at Forrester Beach Resort were reflections of Tommy Forrester's architectural preferences and skill. Some of the houses he built in Osage Beach are still standing and are occupied, but the Highway 54 Expressway that opened in 2011 took much of the Forrester Beach Resort property. Even Forrester Beach Road is now just a fragment of a road.

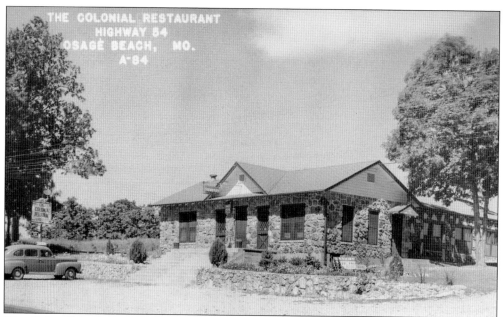

THE COLONIAL RESTAURANT
HIGHWAY 54
OSAGE BEACH, MO.
A-84

The Colonial Restaurant made its appearance along the Osage Beach Parkway in 1946. From the beginning, its advertising claimed that it was "known for good food," and as the years passed, it developed a reputation for sophisticated dining. In the early 1960s, it was open only for the evening meal and offered live entertainment.

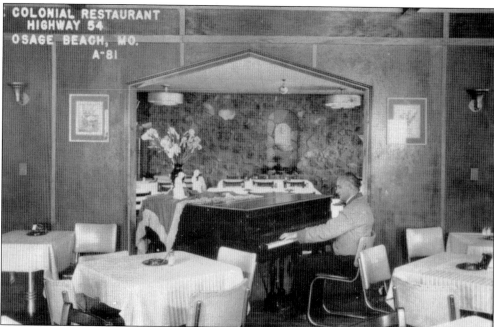

COLONIAL RESTAURANT
HIGHWAY 54
OSAGE BEACH, MO.
A-81

One of the owners at the Colonial Restaurant was an accomplished pianist who would play dinner music on a grand piano in the dining room. The building was remodeled in the mid-1960s with an attractive water fountain out front. The establishment was then renamed the Fountain Restaurant, and its hours were longer. By the late 1980s, the restaurant was gone. A church now occupies the property.

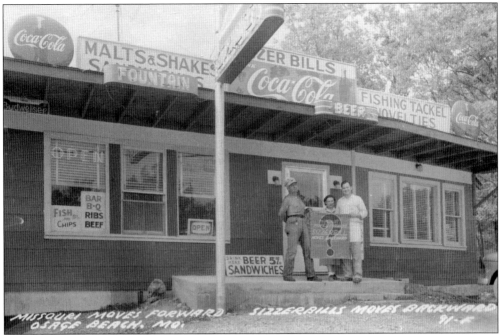

Sizzerbill's Snack Bar made its debut around 1956. The owners, Helen and Harry Roberts, are shown on the right. The man on the left is unidentified. The place was located on the north side of the Osage Beach Parkway, across from the entrance to Malibu Road. Sizzerbill's was gone by the 1980s. (Courtesy of Dale Jeffries.)

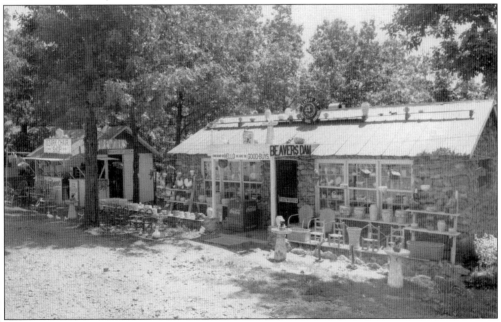

Even though just about every roadside business and most resorts had some type of gift shop and sold souvenirs from the 1930s to the 1970s, it was still possible to operate a roadside gift shop in the 1940s and 1950s and make a decent living. Beaver's Dam Gift Shop was one of the more prominent shops along the Osage Beach Parkway. They also had a few cabins.

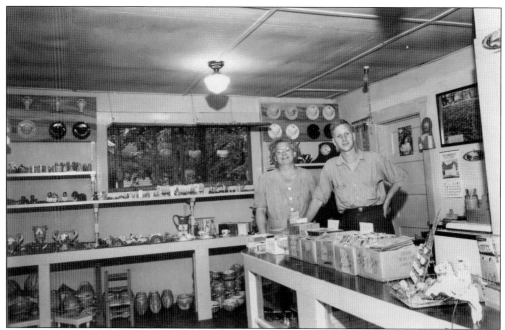

This interior view of the Beaver's Dam Gift Shop shows a couple who may have been the owners. This, along with the photograph on the preceding page, was taken in 1949. Colorful Ozark pottery was a staple item in all the gift shops. Today, the types of souvenirs sold in these shops are collectibles, especially those stamped "Lake of the Ozarks," or "Osage Beach."

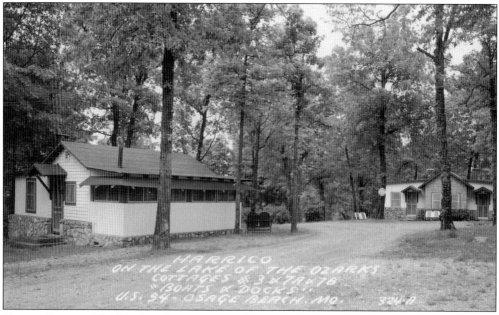

Harrico Resort off Malibu Road in Osage Beach appeared in 1945 advertising, but disappeared about 10 years later. Its advertising specified that it served only a "select clientele." It is not known today what exactly this meant, but it is a phrase often used in those days to mean that African Americans were not welcome. The Malibu Beach Resort used another euphemism that insinuated a similar sentiment.

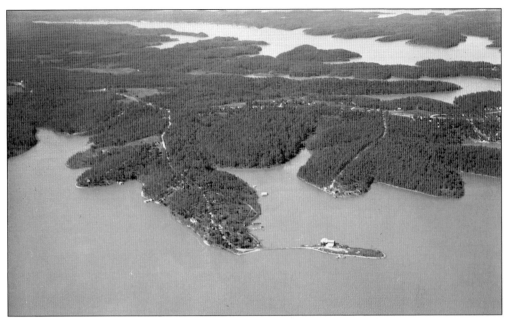

This view of an island attached to a peninsula marks the location of the Malibu Beach Resort, opened by Carl A. Koopman in 1933. His advertisements said that his resort was a "real resort" for "real people." Before the 1960s, much of the Ozark region was off limits to African Americans. "Sundown" towns, or places that were expressly all white, populated the region. (Courtesy of the Missouri State Archives.)

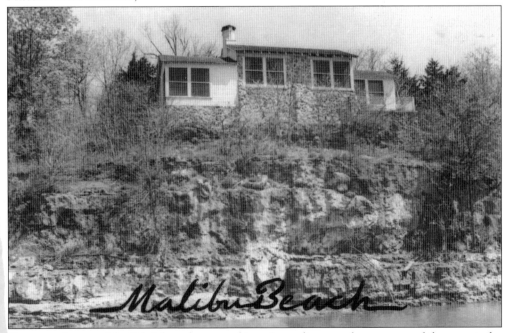

Koopman began with 12 brick and stone cabins. According to a later owner of the resort, the beams inside the cabins came from a bridge that crossed the Osage River before Lake of the Ozarks was created. That bridge may have been one of the many suspension bridges that had to be demolished before the lake basin filled with water. This photograph is from around 1940

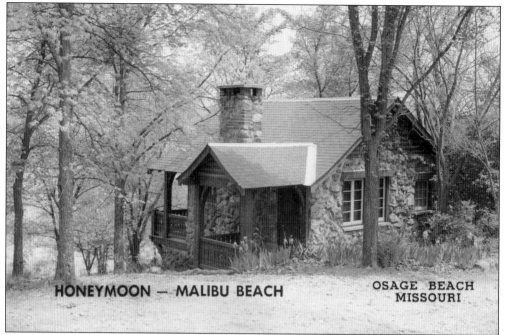

HONEYMOON — MALIBU BEACH

OSAGE BEACH
MISSOURI

The quiet and romantic wilderness of the lake region from the 1930s to the 1970s often made it a destination for honeymooners, and early resort operators took advantage of it. This c. 1940 postcard shows one of the cabins that Malibu Beach Resort reserved for honeymooners. In the 1930s, newlyweds could rent the cabin for $1 per day.

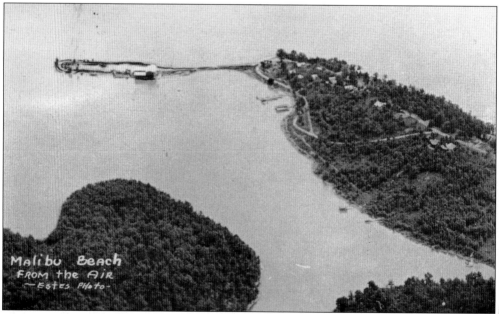

Malibu Beach
FROM the AIR
—Estes Photo—

This view shows how the cabins at the Malibu Beach Resort lined the main road, which went down the spine of the peninsula and then looped around for access to facilities along the water. For a time, a causeway that was used as an enclosed swimming area connected the island. Carl Koopman was from St. Louis.

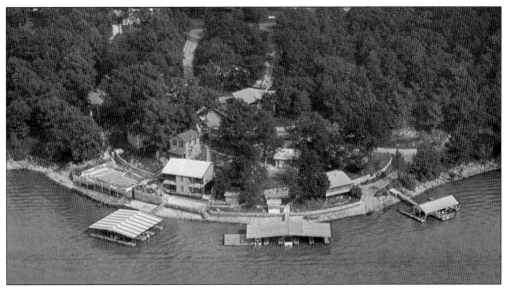

Hap and Ruby Terry established Pla-Mor Beach Resort in 1953. This view from the 1960s shows the resort's well-developed point and shoreline facilities. Around 1959, Hap sold to Ann and Pete Thompson, who were operating the resort when this photograph was taken. The resort was later sold to Pete and Freda Tomasso.

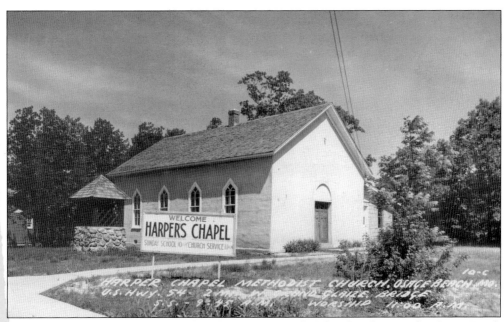

This is an early view of Harper's Chapel in Osage Beach. The church is on the Osage Beach Parkway at the junction of Lake Road 54-56. Both the extensive Harper's Hollow behind the church and the church itself are named for members of the Harper family, who have a history in Camden County dating to 1865. The church stands next to city hall.

Over the past 50 years, the church building has undergone several enlargements and renovations. This image shows the church as it was in 1962. The most recent renovation occurred in just the past decade. The latest enlargement preserved the original chapel and is in the brick building on the left.

Laguna Beach Resort opened in the mid-1930s along the lake off Lake Road 54-45, which was originally Lake Road 18A and is now Case Road. Ted Osborn owned the resort in the 1940s and may have been the original owner. In the 1950s, Doc and Andy Lamis operated the resort.

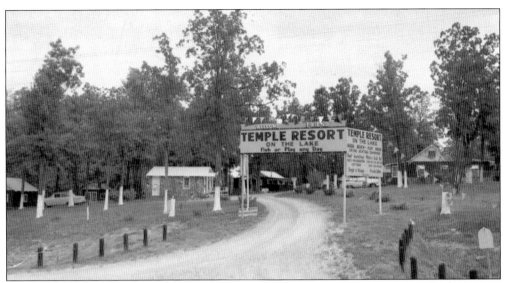

Temple and Unice Hamner opened their resort in 1959. It occupied 17 acres and had both highway and lake frontage. The above image shows the entry that greeted guests driving in during the first few years. Eventually, some connected units faced the highway above (left) and a swimming pool was added on the right.

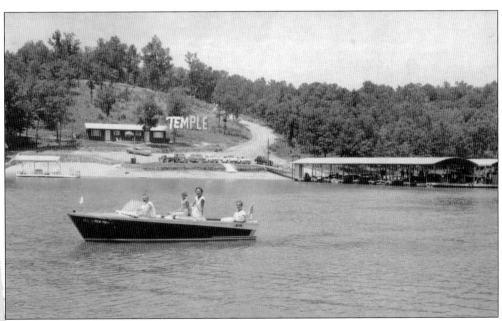

Temple Resort had a noticeable presence on the lake because its sign was made of huge, individual letters. This image shows the first rental units and docks near the beach. The resort's early slogan was "fish or play any day." Guests who stayed at the resort were provided at least one free speedboat ride. Condominiums occupy the property today.

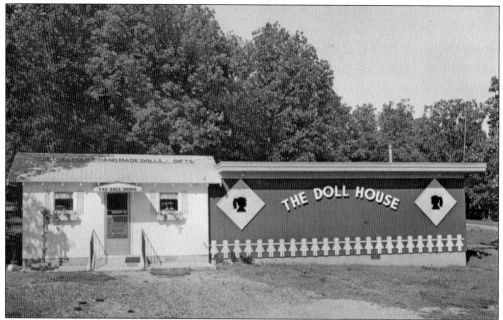

The Doll House was once located along the Osage Beach Parkway, one block or so east of the Route KK junction, and sat back from the roadside. The woman who owned the shop sold handmade dolls and accessories as well as fashionable dolls. She specialized in "apple dolls," or "apple head dolls," which were popular in the 1960s and 1970s.

John and Bob Tilleman opened Antler's Resort in 1954 on Lake Road 20A. They sold to mother and son Leo and Edith Case in 1960, who operated the resort until around 1971, when they sold to Dave and Dot Jones. Ownership changed again in 1978 to Bob and Georgiann Gustin and Wayne and Lois Kline. The resort continued to operate through the 1980s.

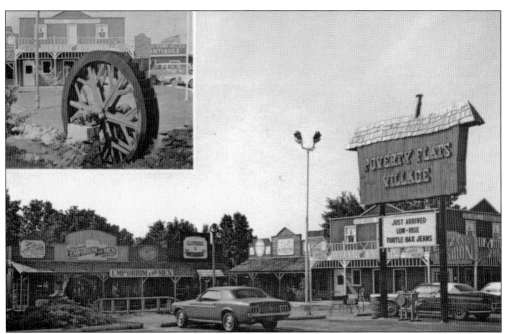

In 1960, Les and Geanie Blair opened Ozark Maid Candies along a desolate stretch of highway in the Osage Beach area and built a retail shop village around it. They named it Poverty Flats. The village grew until it was a prime shopping location. Much upgraded in quality, it is now the Landing on Main Street and home of the Main Street Music Hall.

Melody Beach Resort was established by Jack Krewett in 1948 off Lake Road 20A, which later became Lake Road 54-52. In 1958, he sold to Darryl and Helen York, who kept the resort going until the 1970s. Even in 1970, air conditioning in the units was optional. The advertising was attractive, with the name superimposed over a music bar.

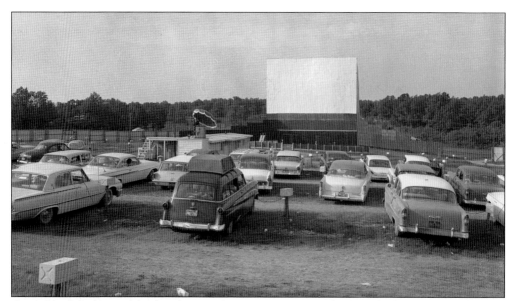

Osage Beach had one of the first drive-in theaters in Missouri. The Grand Glaize Drive-In Theater opened in 1947 and could accommodate about 150 cars. It was located adjacent to the KRMS radio station on the west side. Eventually, Camdenton, Eldon, and Gravois Mills got drive-in theaters in the 1950s. (Courtesy of the Missouri State Archives.)

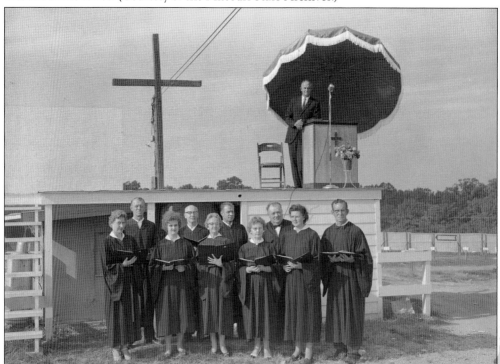

The Grand Glaize Drive-In Theater owners, Grant Scott and Ray Behrens, were members of the Bethany Lutheran Church in Eldon, Missouri, and sponsored nondenominational Sunday worship services at the theater beginning in 1958. Guest ministers hosted services. The theater was in business until the early 1970s. (Courtesy of the Missouri State Archives.)

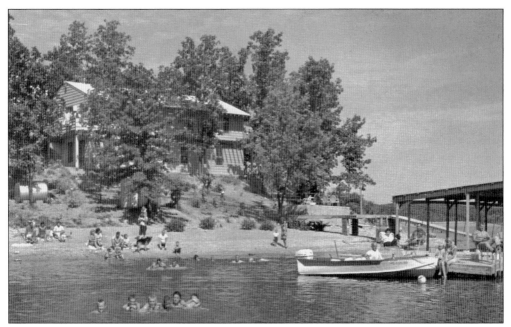

Swydan's Seascape Resort opened in 1962 at the end of Lake Road 54-56 off Route KK. The resort was at the 19.5-mile mark of the Osage Arm. In this early 1960s photograph, guests are seen swimming in the lake. The resort added a heated pool to complement the beach in the late 1960s. In the mid-1970s, the Sheely family owned the resort.

This 1960s photograph shows some of the landmass that comprises Osage Beach on both sides of the Grand Glaize Bridge. It also shows the ponds of the Osage Catfisheries in Harper's Hollow. The fishery was established by the late James W. Kahrs and was the first private warm-water fish hatchery in Missouri. (Courtesy of the Missouri State Archives.)

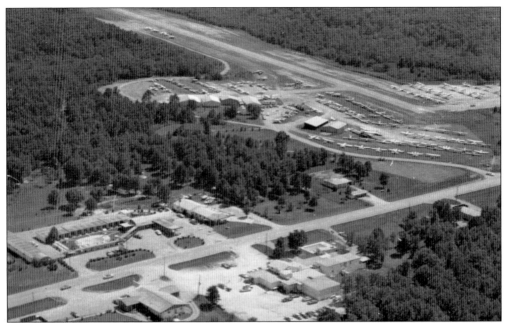

The Linn Creek–Grand Glaize Memorial Airport opened on September 8, 1951. The Linn Creek and Osage Beach Lions clubs sponsored the airport, with financial assistance from state and federal government. Mr. and Mrs. Harry Thompson carved the 3,000-foot runway out of the forest. On the same side of the highway is the Eldorado Lodge.

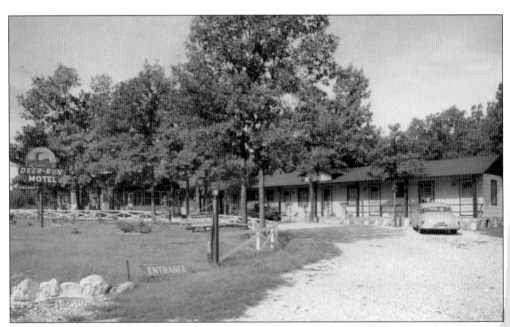

The Deer Run Motel opened in 1952 at the junction of Route KK and Osage Beach Parkway. It was on the northwest corner. The motel survived into the mid-1970s and had a neighbor called the Circle Drive Motel, which opened in 1960 and continued for about the same period of time. A facility of the Central Bank of Lake of the Ozarks now occupies this location.

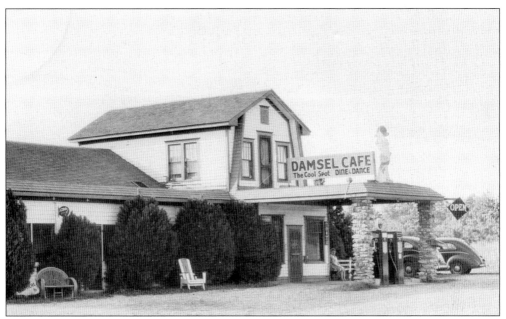

One of the more interesting personalities of the early decades was Quillie Hunter, a native realtor and entrepreneur. He owned the Damsel Café near the Route KK and Osage Beach Parkway junction. "The day will come when the property here will sell for $1,000 a running foot," he predicted in the 1930s. People said he was crazy, but it eventually happened.

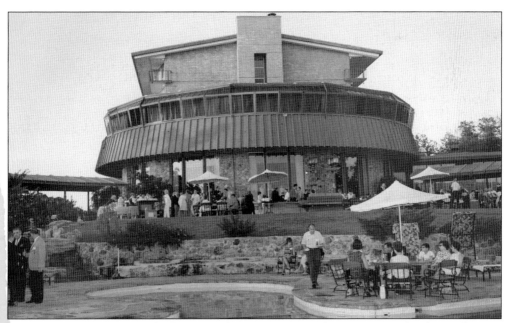

In 1960, Osage Beach was the location where Burton Duenke, a St. Louis developer, chose to build a luxury resort he named Tan-Tar-A, a Blackfoot Indian name that means "he who moves swiftly." Duenke had gotten acquainted with the lake when he visited his brother's fishing cabin at Mallard Point in the 1950s. (Courtesy of the Missouri State Archives.)

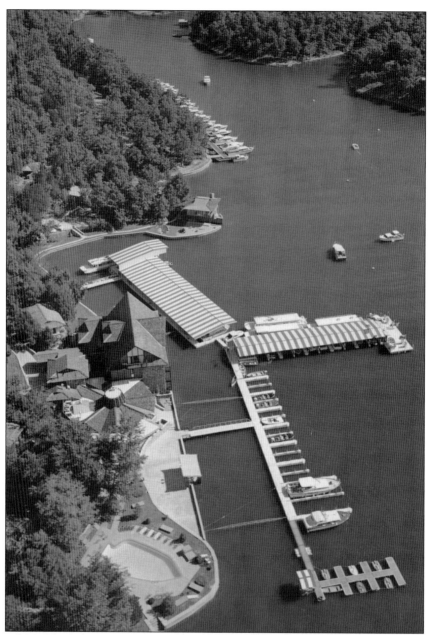

Burton Duenke's right-hand-man during the early work at Tan-Tar-A was Sylvester "Wes" Westhoff, a lifelong friend who was responsible for much of the resort's early architectural design. From 1960 to 1985, the resort was regarded as the "Honeymoon Capital of the Midwest." The resort has a lush Ozark setting along the banks of Lake of the Ozarks, which makes it one of the state's most popular convention centers. Today, it has nearly 1,000 guestrooms, more than 185 suites, and 86,000 square feet of meeting space. It sprawls across hundreds of acres with housing, dining, and entertainment complexes and comprises a small city within itself. In 1977, the resort was bought by the Marriott corporation, and in 2001, the Columbia Sussex corporation took ownership. The resort is one of the largest employers in Osage Beach. This c. 1960 photograph shows development along a portion of the resort's shoreline. (Courtesy of the Missouri State Archives.)

Tan-Tar-A Resort offers great indoor and outdoor entertainment all year. In the late 1960s, the resort built a ski lodge and installed artificial snowmaking machines. The Ozarks hills seemed like a natural setting for winter skiing. Unfortunately, Missouri winters were not consistently cold enough to support the activity. By the late 1980s, the snow machines were gone. Today, a golf course claims the former ski slopes.

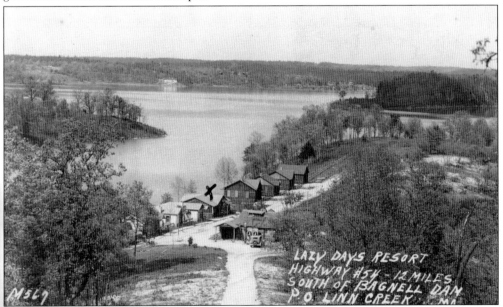

Lazy Days Resort was built between 1931 and 1932 by V. Biggs, who erected cabins on a peninsula at the three-mile mark along the southwest side of the Grand Glaize Arm of the lake. The resort was at the end of Lake Road 54-A25, which is now called Lazy Days Road. The resort occupied the spine of a ridge, and the cabins were 160 feet above the lake.

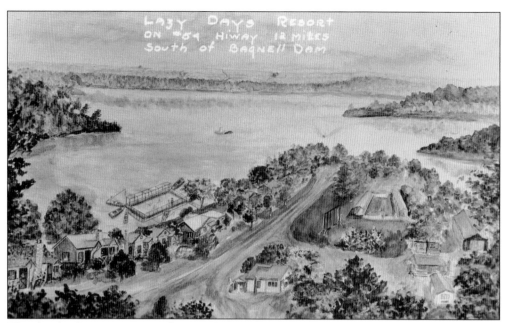

This sketch of Lazy Days Resort by an unknown artist shows a variety of resort features, including some that are not generally seen on the resort's actual photograph postcards from the 1930s through the 1950s. Some of these features include the cabins to the far right, the floating swimming pool, and a playground and recreation area to the right of the main road.

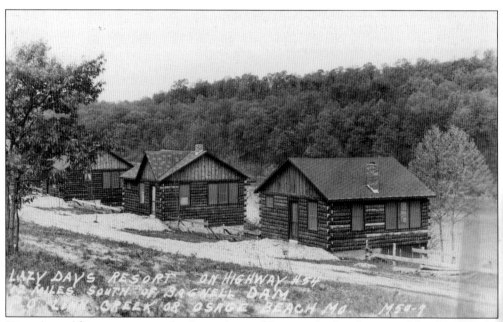

Biggs charged $1 per person per day for a cabin, or $6 per week when he opened, but by 1935, the weekly rate had risen to $10. He had a general store for guest convenience and also sold gas. He said his resort was "a swell place for lazy people." He called his floating swimming pool a "built-in-the-lake-pool." By the 1960s, the owner was Bob Hilton.

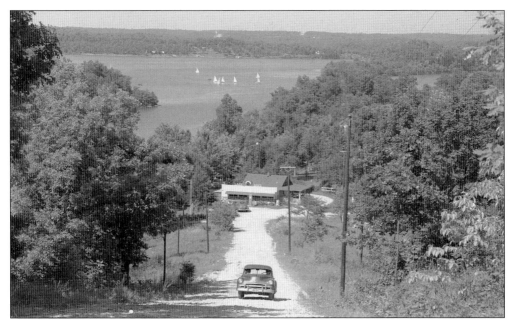

Built on a peninsula, Lazy Days Resort had lakefront on both sides. The resort property is adjacent to Lake of the Ozarks State Park, separated by only a narrow cove. In this 1950s photograph, a car is climbing the hill that leads down to the point. Sailboats add charm to the distant lake view. (Courtesy of the Missouri State Archives.)

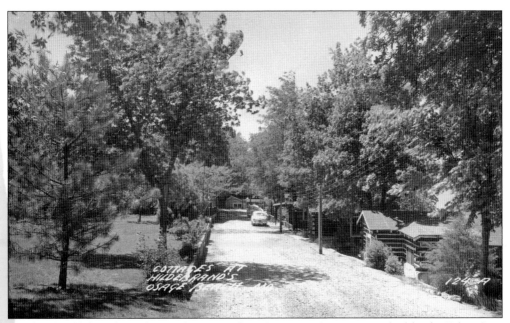

Reinhard Hildebrand, an electrical engineer from Stuttgart, Germany, worked for the Fulton Iron Works in St. Louis and established Hiltebrand Resort at the 28-mile mark of the lake's main arm in 1935. This location was at the end of Lake Road 54-59 just west of Route KK. This photograph shows the main drive along the resort's row of log cabins.

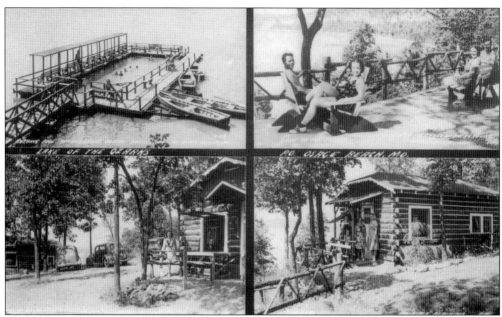

Hildebrand Resort was very popular. This four-image postcard gives a good impression of the resort, which had a grand view of the Palisades, an impressive bluff area along the lake. Since a good portion of the resort was high above the lake, Hildebrand had a walking trail going along the ridge with places for guests to sit and enjoy the scenery, like the overlook shown at upper right.

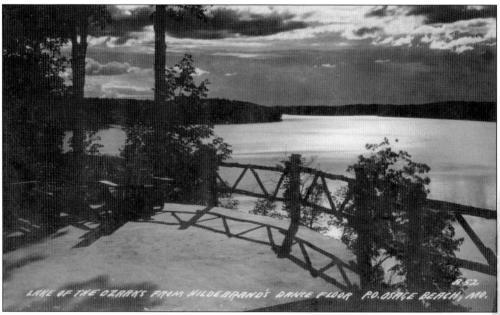

Hildebrand was a romantic at heart and promoted to honeymooners. Moonlight dances were hosted on this deck at Hildebrand Resort. Resorts used real-photograph postcards as a form of advertising in the 1930s, 1940s, and 1950s. Every resort had its own unique set, and most sets included a tranquil moonlight or sunset scene.

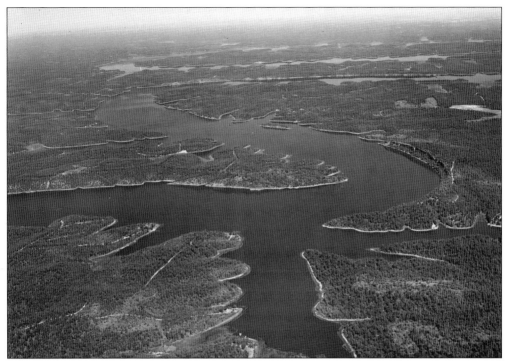

This view shows four major Lake of the Ozarks peninsulas. From the top down are Horseshoe Bend, Shawnee Bend, Turkey Bend, and Linn Creek Bend. All of Turkey Bend is part of Osage Beach. Linn Creek Bend (middle left) points to one of the great natural features in the Osage Beach area, the Palisades. (Courtesy of the Missouri State Archives.)

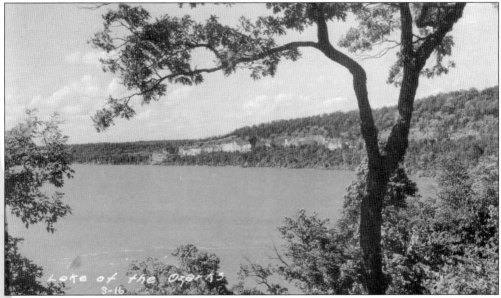

This was Hildebrand's view of the Palisades. The bluff line, towering to heights 200 feet above the lake, extends for one mile in a gentle curve. This view was one of the selling points for the Hildebrand Resort. Today, the resort property belongs to Brent Boyles and is the home of Michael's Steak House.

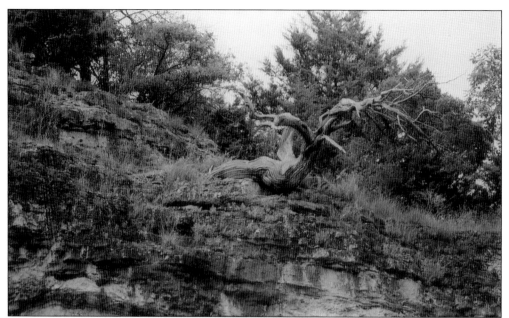

Lake of the Ozarks meanders along the old course of the Osage River for nearly 100 miles and has 1,150 miles of shoreline. Great bluffs make the lake especially scenic, as do the ancient cedar trees, both living and deceased. This gnarled corpse may have been alive when Zebulon Pike explored the river passage in 1806.

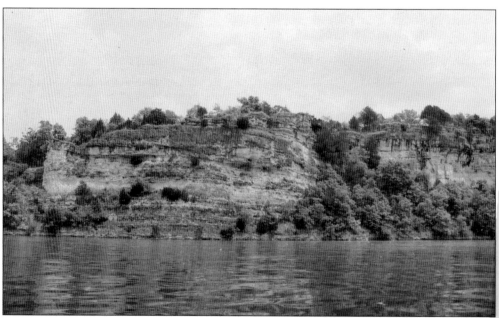

The water along the Palisades is 50 to 70 feet deep. In the days of Zebulon Pike, these bluffs would have appeared even higher above the Osage River which, except during a flood, was never very deep. This is some of the oldest sedimentary rock exposed on the surface in Missouri and is so old that it contains almost no fossils.

Four

ATTRACTIONS AND ENTERTAINMENT

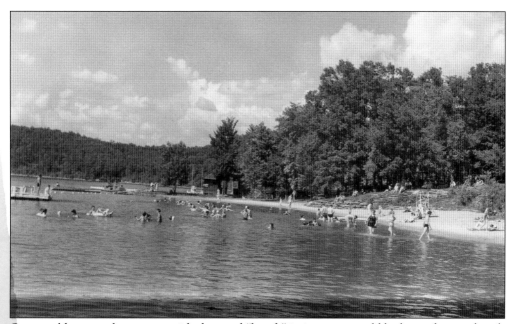

One would expect that a town with the word "beach" in its name would be located near a beach of some distinction. The beach shown in this 1950s photograph is Public Beach No. 1 in Lake of the Ozarks State Park. The park maintains two public beaches. (Courtesy of the Missouri State Archives.)

Lake of the Ozarks State Park began as part of the National Industrial Recovery Act of 1933 and was originally a "recreational demonstration area" under the jurisdiction of the National Park Service. The park is on both sides of the Grand Glaize Arm of the lake and includes 85 miles of the lake's shoreline. (Courtesy of the Missouri State Archives.)

Early work on the park was carried out by the Civilian Conservation Corps, which also created youth camps, such as Camp Red Bud, Camp Pin Oak, Camp Hawthorn, Camp Clover Point, and Camp Rising Sun. Boy Scouts, Future Farmers, 4-H clubs, and YMCA groups began using the park. Above is Public Beach No. 2. (Courtesy of the Missouri State Archives.)

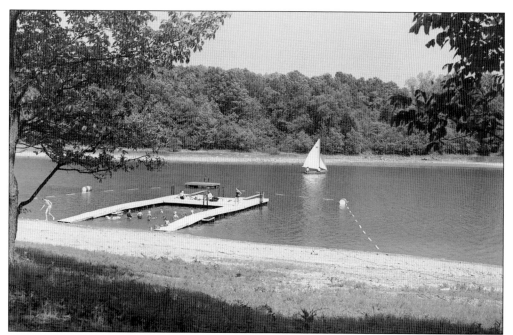

In 1946, the park's ownership was transferred to the state of Missouri and it became Lake of the Ozarks State Park. Public campgrounds, beaches, boat launches, and fishing facilities were created. In time, it would have hiking trails, designated natural areas, and even a major airport called Lee C. Fine in the 1960s. (Courtesy of the Missouri State Archives.)

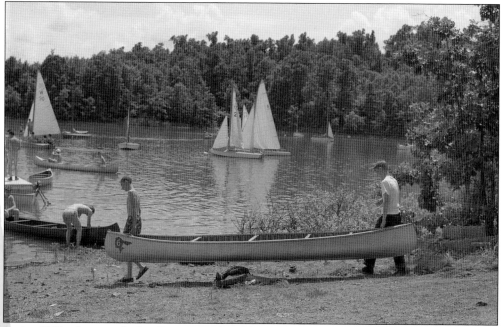

In this 1960s photograph, Sea Scouts at Lake of the Ozarks State Park set about launching canoes. The park covers 17,200 acres. The park's broad diversity of flora and fauna is outstanding. In winter, bald eagles can be seen flying over the coves. The park even touts its colorful scarlet snake that comes out at night to feed. (Courtesy of the Missouri State Archives.)

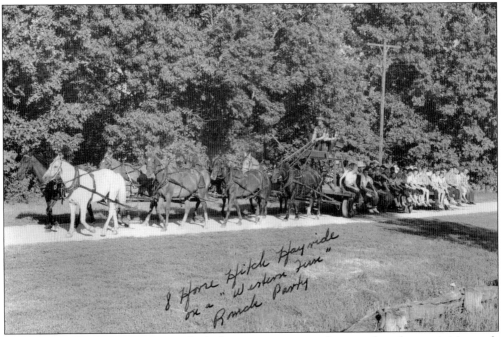

8 Horse Hitch Hayride on a "Western Fun" Ranch Party

The 1950s and 1960s were years in which the country-western theme and outdoor activities, such as wagon rides, hayrides, cookouts, and barn dances, had a high profile in the recreational arena that was represented by Osage Beach. Here, a youth group enjoys an eight-horse hayride at Lake of the Ozarks State Park. (Courtesy of the Missouri State Archives.)

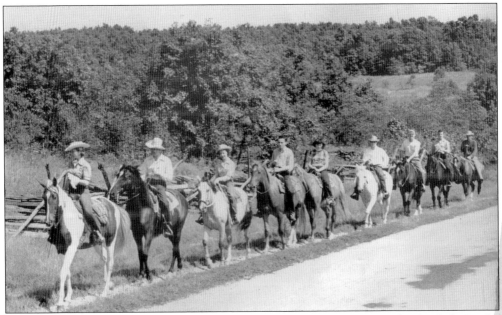

The Ozark Homestead operation within the park sponsors a variety of trail rides daily. In the 1950s and 1960s, the Western Fun Ranch, operated by Tex and Hope Varner, organized other trail-riding activities. The ranch was just outside the park. Its Western Fun Rodeo was later renamed the Ozark Stampede. (Courtesy of the Missouri State Archives.)

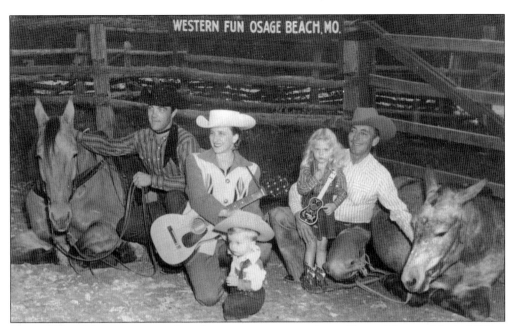

Tex and Hope Varner, mentioned on the previous page, are pictured here with two of their children along with Chuck Grimes, the rodeo's head wrangler. From left to right are Chuck with his trick horse, Buck; Hope Varner with son Dickson Drew; Tex Varner with daughter Gay Linell; and Tex's educated mule, Harry. The Varners' third child, Victoria Star, was not yet born.

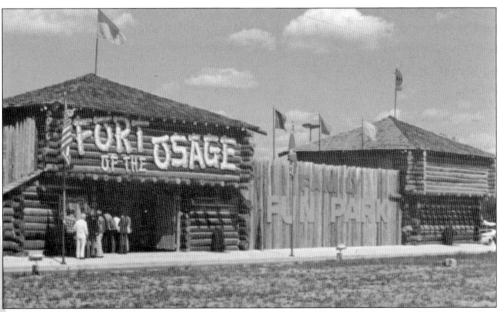

Fort of the Osage Fun Park opened near the junction of Osage Beach Parkway and Highway 42 in the mid-1970s. The family fun park featured a frontier fort, a museum, crafts, stage shows, rides, a steam train, and a high tower ride that took visitors in an enclosed car to a height of more than 150 feet. The theme park closed in the 1980s.

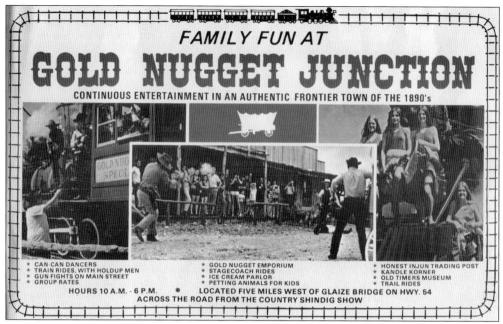

FAMILY FUN AT
GOLD NUGGET JUNCTION
CONTINUOUS ENTERTAINMENT IN AN AUTHENTIC FRONTIER TOWN OF THE 1890's

* CAN-CAN DANCERS
* TRAIN RIDES WITH HOLDUP MEN
* GUN FIGHTS ON MAIN STREET
* GROUP RATES

* GOLD NUGGET EMPORIUM
* STAGECOACH RIDES
* ICE CREAM PARLOR
* PETTING ANIMALS FOR KIDS

* HONEST INJUN TRADING POST
* KANDLE KORNER
* OLD TIMERS MUSEUM
* TRAIL RIDES

HOURS 10 A.M. - 6 P.M. ● LOCATED FIVE MILES WEST OF GLAIZE BRIDGE ON HWY. 54
ACROSS THE ROAD FROM THE COUNTRY SHINDIG SHOW

Gold Nugget Junction, a western theme park, opened around 1974. It was located on the western edge of Osage Beach across the highway from Lazy Days Road. It featured frontier gunfights, magic shows, a petting zoo, country music shows, a steam train, and a western frontier city with nearly 30 buildings. It remained open until the early 1980s.

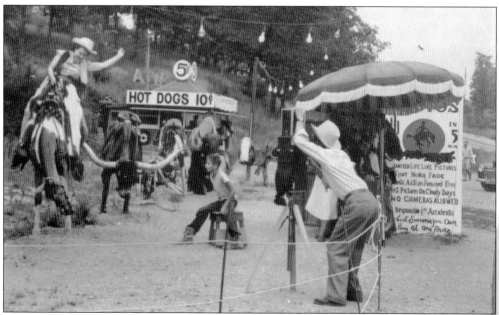

Beginning in the 1950s and continuing into the early 1980s, Tex and Mae Bemis provided a lot of entertainment for tourists. They had roadside and lakeside attractions in both Osage Beach and Lake Ozark at various times. Here, Tex is set up with his stuffed animals as his wife, Mae, poses on the bucking horse. (Courtesy of James Brooks.)

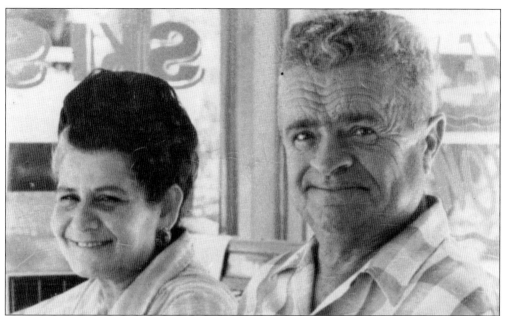

Thurman "Tex" Bemis was noted for his sense of humor, wit, and ready smile. He was born in Spearman, Oklahoma, in 1912. He married Mattie Mae Bratcher in Miami, Oklahoma, in 1938, and they came to Lake of the Ozarks in 1950. They are pictured here when they operated the Ozark Water Ski Thrill Show. (Courtesy of James Brooks.)

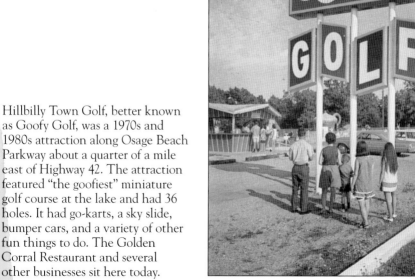

Hillbilly Town Golf, better known as Goofy Golf, was a 1970s and 1980s attraction along Osage Beach Parkway about a quarter of a mile east of Highway 42. The attraction featured "the goofiest" miniature golf course at the lake and had 36 holes. It had go-karts, a sky slide, bumper cars, and a variety of other fun things to do. The Golden Corral Restaurant and several other businesses sit here today.

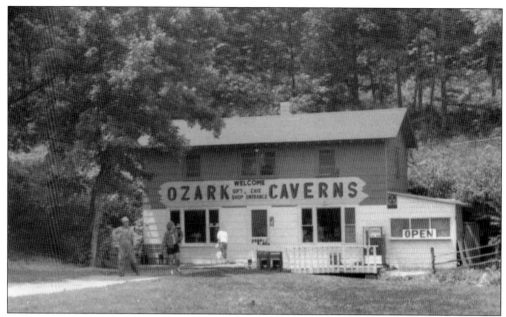

Ozark Caverns opened to the public for guided tours in 1953. When the state park was created, there were some privately owned in-holdings, such as the property where this cave is located. The state purchased this property and cave in 1978. This early 1960s photograph shows the cave entrance building before the cave was acquired by the state.

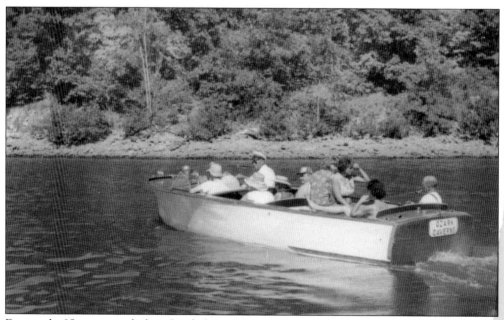

During the 25-year period when Ozark Caverns was a private operation, it was a drive-in or boat-in attraction. The cave operation had a concession to operate out of Lake of the Ozarks State Park Public Beach No. 1. People who took the tour got a seven-mile speedboat ride, a one-and-a-half-mile wagon ride through a rugged woodland area, and a tour of the cave.

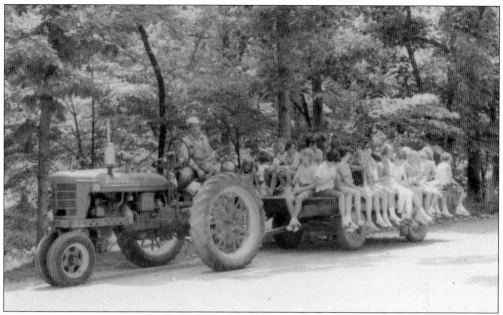

Robert Blankenship, a native of the Ozarks Caverns locale, drove the tractor that pulled the wagon for the Ozark Caverns woodland ride. A group of Girl Scouts are shown here in the summer of 1964 after their tour of the cave. For a time, the cave operation also had a speedboat–barbeque–cave tour package that operated out of Link's Landing at the Grand Glaize Bridge.

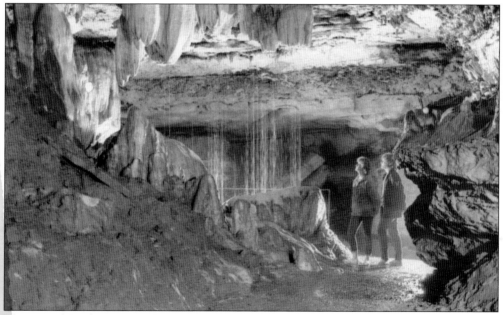

The tour of Ozark Caverns takes visitors on a three-quarter-mile journey underground to see some of the finest subterranean scenery in the lake area. Here, two young women look at the natural and continuous rain of spring water that makes the Angel's Shower one of the cave's highlights. The cave is spacious and has many formations.

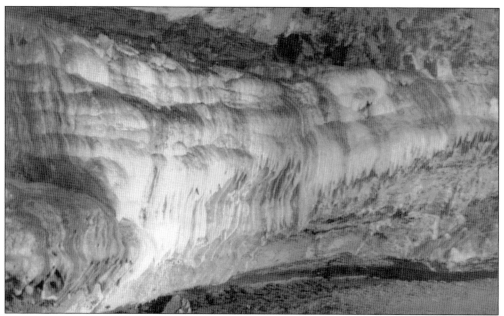

Along the broad, main corridor of Ozark Caverns are numerous flowstone cascades, like the one shown here known as Rainbow Falls. Mineral water seeping and flowing over ledges has slowly created crystalline cascades of calcite. Many of the formations in the cave are pure white, while others have blended tints of gray to black.

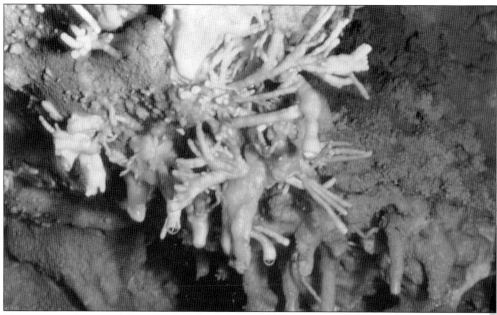

The cave is also noted for its many displays of delicate formations known as helictites on its ceiling and walls. These formations are in a cavity along the wall of the main corridor. Note the one that has taken the shape of a miniature hammer. Even as small as these formations are, it has probably taken them hundreds of years to reach their present size.

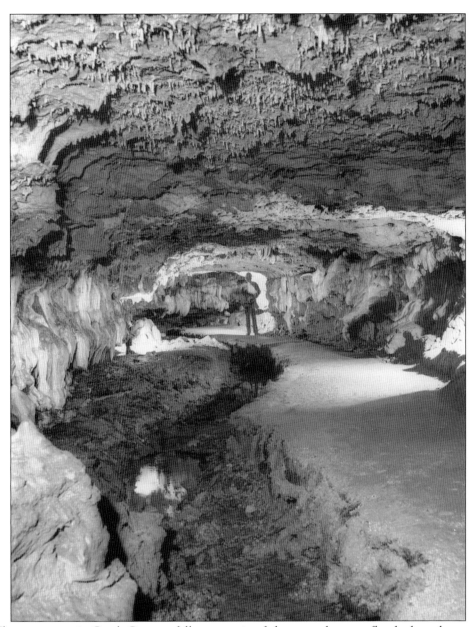

The tour route in Ozark Caverns follows a spring-fed stream that can flood when there are excessive amounts of rainfall, but such floods, which can close the cave to touring, do not happen often. This photograph demonstrates a technique used by some cave photographers that results in "ghosting." The camera lens is opened in total darkness and the lens is left open on a timer while the photographer walks forward, setting off flashes. This neatly lights the passage and gives the photographer a ghostly image as he is caught by successive flashes. Ozark Caverns is a habitat for five species of bats, four species of salamanders, and 16 species of invertebrates. Removal of electrical lighting by the state and returning to a system of each visitor carrying a lantern has benefitted the cave life by darkening the environment. The cave is a pleasant 56 degrees Fahrenheit year-round and lies some 200 feet beneath the surface. There is a visitor's center, natural fens, springs, and hiking trails on the surface in the vicinity of the cave.

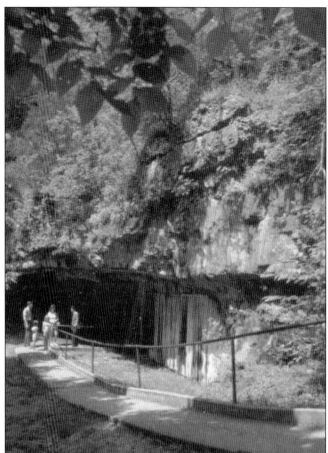

Indian Burial Cave, a second cave that calls Osage Beach home, was open to the public in the 1960s, 1970s, and early 1980s. The cave is located high on a bluff overlooking the Osage River below Bagnell Dam. In 1959, several Indian burials were unearthed in the cave's entrance. The burials became a tour highlight. Visitors also got a tram ride down the hillside and a short underground boat ride.

The Fort Osage Water Show opened around 1976 near the junction of Osage Beach Parkway and Highway 42, but was on the lake. It was a professional water show and ski school. Performances included various types of acrobatic skiing, such as pyramids and water ballet. In the early 1980s, the show was renamed Lake of the Ozarks Water Show. It no longer exists.

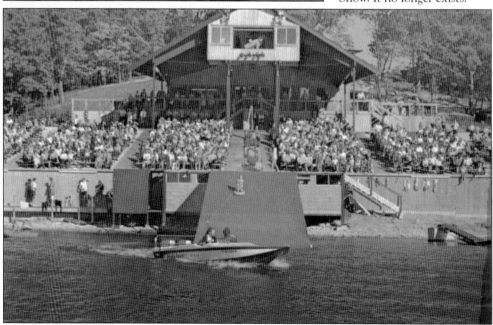

Aquarama, called Cabaret Aquarama when it opened, was an attraction that provided a meal featuring Chinese, Cantonese, Polynesian, and American food. It took place in a theater setting while swimmers performed an underwater ballet-type show behind crystal plate glass, which covered one side of a water tank 50 feet long. The theater was located in Osage Beach east of Passover Road and was adjacent to the Golden Door Motel.

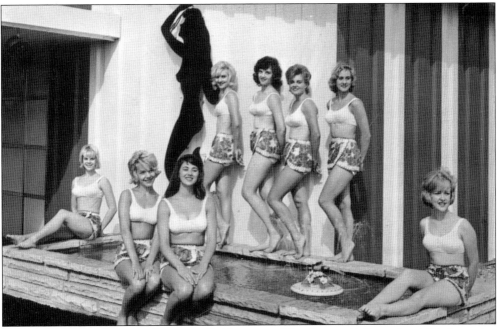

Most of the young women performers, called "aqua maids" or "mermaids," were local. Their routine consisted of six 30-minute skits set to music. Their final routine was called "Life is a Cabaret." The show was in existence for about 10 years, opening in the mid-1960s and closing in the mid-1970s. The building later became the home of the Happy Fishermen Restaurant.

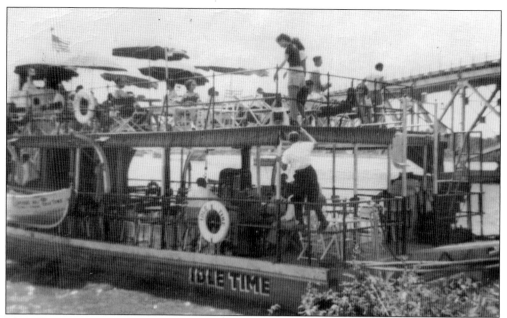

The *Idle Time* excursion boat began service at the east end of the Grand Glaize Bridge in the early 1940s. Its home port was Chet's Anchor Inn. The *Gov. McClurg* excursion boat was its competition at the west end of the bridge. Speculation has it that during the latter half of the 1940s, wartime rationing hampered tourism, making the boat's operation unprofitable.

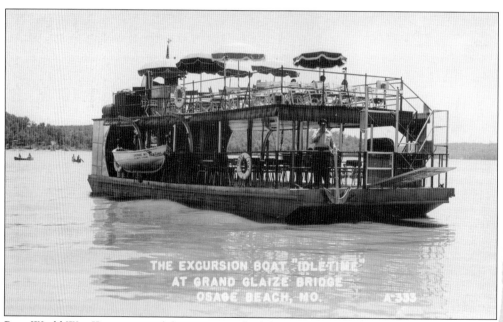

Post–World War II prosperity did not impact the lake area in a big way until the mid-1950s. In 1951, the *Idle Time* was taken out of the lake, put back in the water at Tuscumbia, and piloted down the Osage River to the Missouri River. It then took the Mississippi River to the Red River, which it followed until reaching Lake Tecoma in Texas.

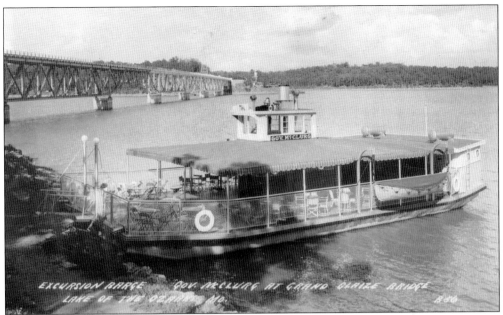

When Lake of the Ozarks was formed, it severed Highway 5 between Camdenton and Versailles in two places. Until 1937, the *Gov. McClurg* was a ferry operation to compensate for the lack of bridges on Highway 5. When the bridges were complete, the *Gov. McClurg* ferry was converted into the *Gov. McClurg* excursion boat.

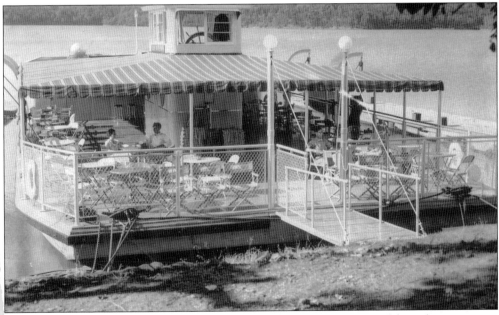

For a brief time, the *Gov. McClurg*, named for Camden County's most celebrated statesman in the years following the Civil War, was located near Bagnell Dam. It was moved to the west end of the Grand Glaize Bridge before 1940, where it continued to operate until 1968, when it was purchased by the Lodge of the Four Seasons, renamed, and relocated.

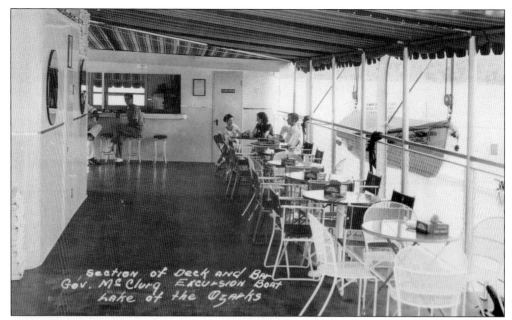

Section of Deck and Bar
Gov. McClurg Excursion Boat
Lake of the Ozarks

PERCY FRANKS
"THE LAST OF THE"
RAGTIME KIDS

The *Tom Sawyer* and *Captain Larry Don* excursion boats are the only excursion boats that have been in service on Lake of the Ozarks longer than the *Gov. McClurg*. The *Gov. McClurg* was a favorite of graduating seniors throughout central Missouri in its day. The author remembers being on a moonlight dance cruise on the *Gov. McClurg* when he was a senior in high school.

Through the years, a variety of bands and musicians entertained people on the *Gov. McClurg*. Percy Franks was one of the favorites, especially for older adults who enjoyed ragtime music. Daytime excursions were short. The moonlight cruise, which began at nine p.m. each evening in season, lasted for three hours and traveled 15 miles roundtrip.

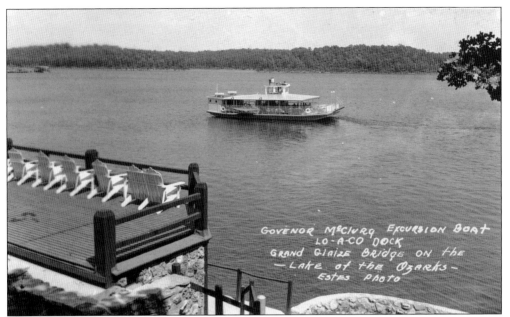

GOVENOR McCLURG EXCURSION BOAT
LO-A-CO DOCK
GRAND GLAIZE BRIDGE ON the
—LAKE of the Ozarks—
Estes Photo

This image of the *Gov. McClurg* getting underway is a companion to the photograph seen at the bottom of page 63. The corner of the building seen here is the building seen along the shore in the photograph on page 63. The *Gov. McClurg* has been gone for more than 40 years, but many people still cherish memories of the boat.

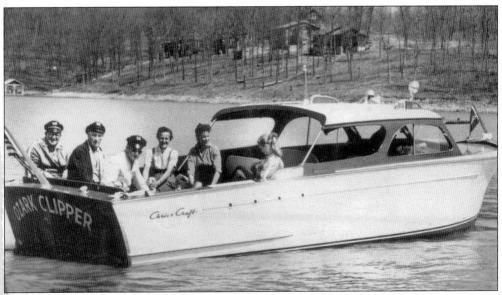

In the 1960s, the *Ozark Clipper* was called "the Luxury Liner of the Lake." It sailed out of Link's Landing (see page 22) twice a day, at 11:00 a.m. and 2:00 p.m., for Ozark Caverns, and at 6:00 p.m. for an Ozark barbecue trip. Sitting in the back of the boat (second from left) is Capt. R.H. "Ohle" Ohlson.

It is an understatement to say that boating in the early days compared to today is like the difference between day and night. Regattas and races were popular in the early years, but today, powerboats 17 to 60 feet in length can reach speeds over 150 miles per hour and give the lake scene new meaning in powerboat racing events. (Courtesy of the Missouri State Archives.)

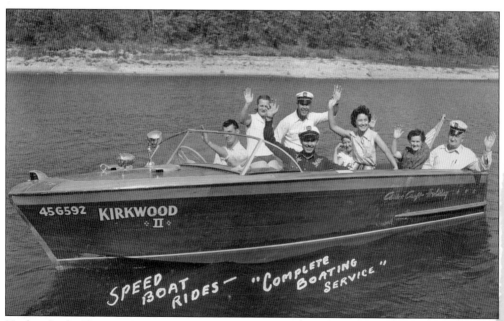

Hacker Craft, Chris Craft, Century, and Gar Wood runabouts were top-of-the-line in boating on the lake in the 1930s. These are what we think of now as the "woodies" of yesterday. Although these brands of mahogany-trimmed boats can still be found on the lake, today they most often show up as restorations and are displayed primarily in boat shows.

Bob Nolan (front center) opened his Country Music Hall about two miles east of the Osage Beach Parkway on Highway 42 around 1968. He had an unusual rotating stage and the auditorium seats surrounded it. During a performance, the stage slowly rotated so the band was facing everybody periodically. The building now houses a church.

The Chuck Watkins Ozark Jamboree Country Music Show succeeded the Bob Nolan Country Music Hall Show in the same auditorium on Highway 42. These shows were popular in the 1960s and 1970s. It was a time when "hillbilly" and "country western" music was very popular with the lake's Midwestern audience. Watkins is in the back row center.

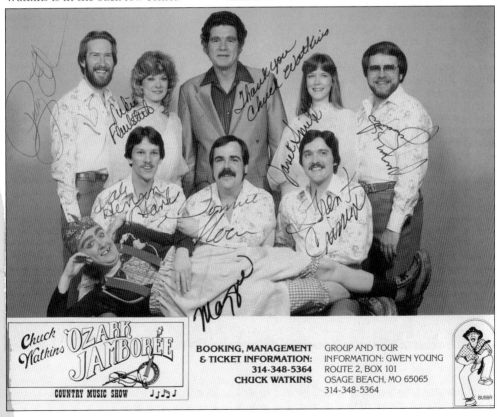

Chuck Watkins OZARK JAMBOREE COUNTRY MUSIC SHOW

BOOKING, MANAGEMENT & TICKET INFORMATION: 314-348-5364 CHUCK WATKINS

GROUP AND TOUR INFORMATION: GWEN YOUNG ROUTE 2, BOX 101 OSAGE BEACH, MO 65065 314-348-5364

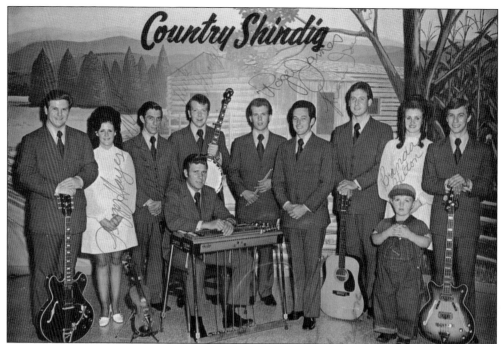

Denny Hilton's Country Shindig Music Show opened around 1970 in a large auditorium at the entrance to Lazy Days Road. During its 15- to 20-year run, it entertained thousands of visitors. Some band members changed from season to season, but a few of the musicians remained with the show throughout its lifetime. Hilton is standing sixth from the left.

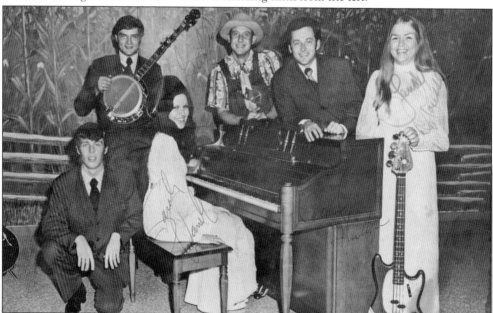

In this photograph, Denny Hilton is second from the right. Several of these musicians went on to become stars of the Main Street Opry, which is the only country music group regularly performing in Osage Beach at present. It is located at Blair's Landing in the Main Street Music Hall. Its show also includes popular music.

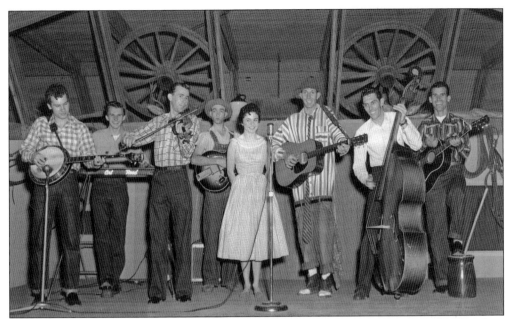

Lee Mace's Ozark Opry was the first country music show to open in Osage Beach. The show started in Lake Ozark in 1953, but relocated to Osage Beach when Lee and Joyce Mace built their auditorium in 1957. The auditorium had a seating capacity of 1,000 and also housed recording and video production facilities. Lee Mace is second from the right.

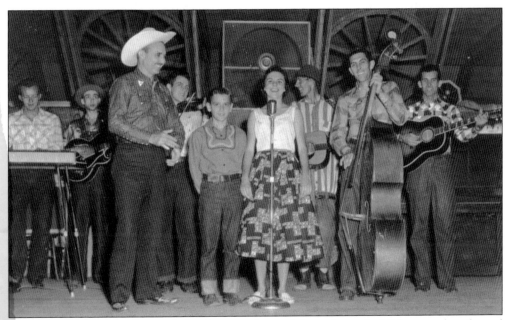

During winter months, Lee took the show on the road throughout the Midwest and performed on KRCG-TV. Their success helped popularize the lake area. Lee died in 1985. Joyce Mace kept the show going for another 20 years. Here, square dance promoters Les Gotcher (left) and Lee Mace are pictured at the Ozark Opry in the 1950s.

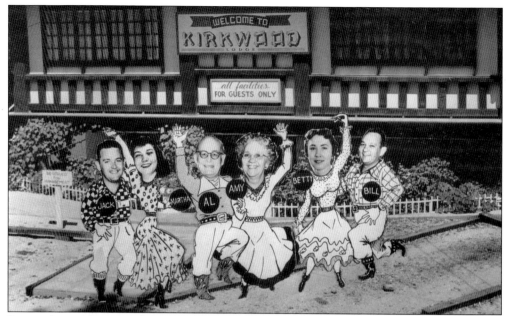

Square dancing became a hit at Lake of the Ozarks in the 1950s. In Osage Beach, the focal point was at Kirkwood Lodge, where the Hagadorn family teamed up with famed square dance caller Les Gotcher from the west coast and created a "square dance institute." This postcard was created to introduce the Hagadorns to attendees.

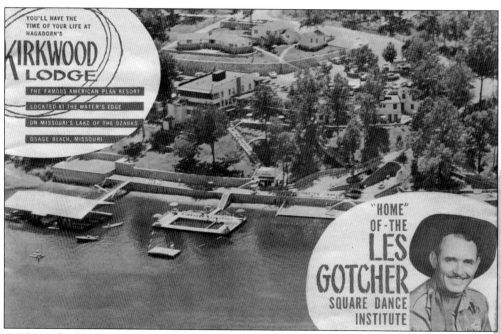

A 16-page booklet was created to promote Kirkwood Lodge Resort and the square dance institute. Les Gotcher (1905–1996) became one of America's most colorful square dance callers. He was born in Texas, but spent most of his life in California. He worked in the motion picture industry and called many square dances for Hollywood films.

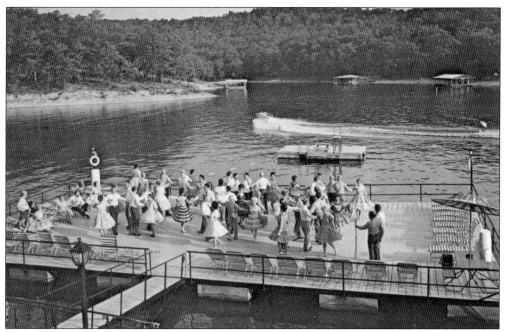

Les Gotcher called one of the first square dance institute sessions at Kirkwood Lodge in the early 1950s. To get it started, Les used his own private mailing list and invited 50 couples. The setting of the institute made it very popular at the lake. Square dancing is still going strong at Kirkwood Lodge. The lodge created this postcard to encourage square dance vacations.

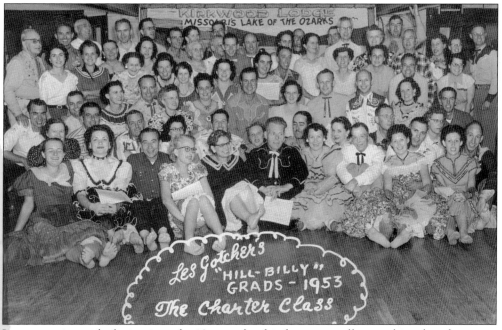

Les was active with the institute for 10 years, but his fame as a caller sent him abroad, even to Europe. The institute has produced many of the nation's top square dance callers over the past 58 years, and they took over after Gotcher's departure. The photographs shown here come from photograph albums produced during the early institutes.

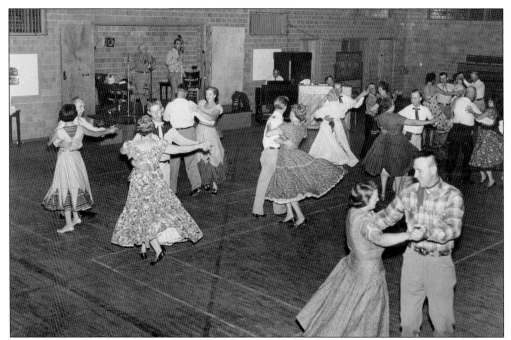

Square dancing became popular at many locations in the Osage Beach and Lake Ozark areas in the 1950s and 1960s as a consequence of Bill Hagadorn and Les Gotcher's activities as well as those of Lee and Joyce Mace of the Ozark Opry. Above is a square dance taking place at the School of the Osage gymnasium in the 1950s. (Courtesy of Sue Dutton.)

Participants in the square dance school (called an "institute" after 1952) in the 1950s and 1960s earned what was often called a "square dancin' hillbilly diplomie," like the one shown for Doc Bob and Virginia Gannon, dated September 18, 1952. Bill Hagadorn and other members of the Hagadorn family signed it.

When Les Gotcher conducted the square dance institute at Kirkwood Lodge in the 1950s, he always managed to get in some fishing. He is shown here in a fishing boat displaying his catch. The 1950s was a transition period when wooden fishing boats gave way to aluminum boats, which would in turn be replaced by fiberglass boats.

Lake of the Ozarks is a sportsman's lake. It has huge populations of game fish, including white and black bass, white and black crappie, largemouth and spotted bass, bluegill, walleye, and three types of catfish—channel, flathead, and blue. Here, an early fisherman displays his catch. (Courtesy of the Camden County Historical Society.)

In the 1930s, 1940s, and early 1950s, duck hunting as well as fishing was popular at the lake, but as the population of resorts and homes along the lake multiplied in later decades, hunting declined. Fishing has continued to hold strong. These fellows displayed their catch while also promoting the resort at which they were staying.

Railroad ties spawned the village of Zebra in 1886. Forty-five years later, Lake of the Ozarks inundated Zebra landing, and the village was reborn as Osage Beach. The bridge at its heart linked land, water, and people to create a recreational jewel in the Ozarks. The people and businesses featured in this book were among the pioneers who made it all possible. (Courtesy of the Missouri State Archives.)

BIBLIOGRAPHY

Burke, Lorraine. *50th Anniversary Bagnell Dam 1931–1981*. Lake Ozark, MO: Lake of the Ozarks Council of the Arts, 1981.

Flader, Susan. *Exploring Missouri's Legacy, State Parks and Historic Sites*. Columbia, MO: University of Missouri Press, 1992.

Gotcher, Leslie Louis and Wendy Taheri. *Dancing Among the Stars*. Hilo, Hawaii: Les Gotcher, 1993.

Helbock, Richard W. *United States Post Offices Volume VII—The Lower Mississippi Valley*. Scappose, OR: La Posta Publications, 2005.

Hubbell, Victoria. *A Town On Two Rivers, A History of Osage Beach, Missouri*. City of Osage Beach, 1998.

Lake of the Ozarks information advertising booklet. Lake of the Ozarks Association, various issues, 1950–1980.

Lake of the Ozarks reference maps. Lake of the Ozarks Association, various editions, 1935 1975.

Missouri: A Guide to the "Show Me" State. American Guide series. New York: Duell, Sloan, and Pearce, 1941.

Osage Beach Area information advertising booklet. Osage Beach Chamber of Commerce, various issues, 1950–1980.

Peek, Dan William. *Live! At the Ozark Opry*. Charleston, SC: History Press, 2010.

Weaver, H. Dwight. *History and Geography of Lake of the Ozarks, Volume One*. Eldon, MO: Osage River Trails, 2005.

———. *History and Geography of Lake of the Ozarks, Volume Two*. Eldon, MO: Osage River Trails, 2008.

———. *Lake of the Ozarks: The Early Years*. Charleston, SC: Arcadia Publishing, 2000.

———. *Lake of the Ozarks: Vintage Vacation Paradise*. Charleston, SC: Arcadia Publishing, 2002.

Discover Thousands of Local History Books
Featuring Millions of Vintage Images

Arcadia Publishing, the leading local history publisher in the United States, is committed to making history accessible and meaningful through publishing books that celebrate and preserve the heritage of America's people and places.

Find more books like this at
www.arcadiapublishing.com

Search for your hometown history, your old stomping grounds, and even your favorite sports team.

Consistent with our mission to preserve history on a local level, this book was printed in South Carolina on American-made paper and manufactured entirely in the United States. Products carrying the accredited Forest Stewardship Council (FSC) label are printed on 100 percent FSC-certified paper.

MADE IN THE USA